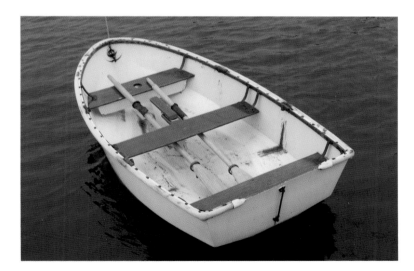

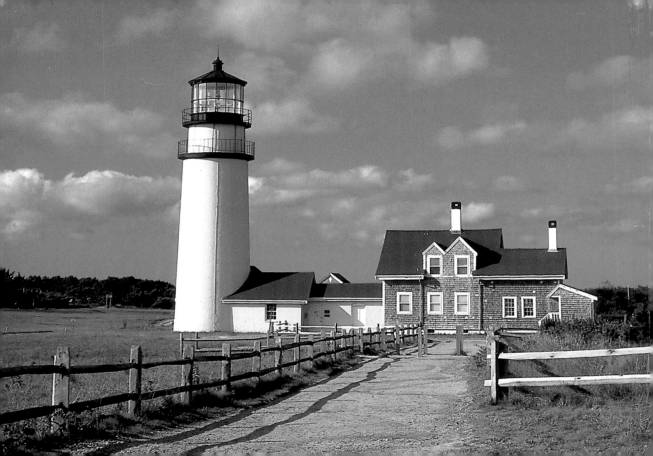

CAPE COD
AND THE ISLANDS

Photographs by JAKE RAJS

RIZZOLI

First published in the United States of America in 2008
by RIZZOLI INTERNATIONAL PUBLICATIONS, INC.
300 Park Avenue South
New York, NY 10010
www.rizzoliusa.com

2008 2009 2010 2011 2012 / 10 9 8 7 6 5 4 3 2 1

Design by Susi Oberhelman
Printed in China

ISBN-10: 0-8478-3103-5
ISBN-13: 978-0-8478-3103-6
Library of Congress Catalog Control Number: 2007938767

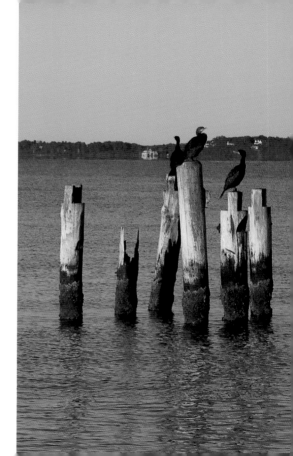

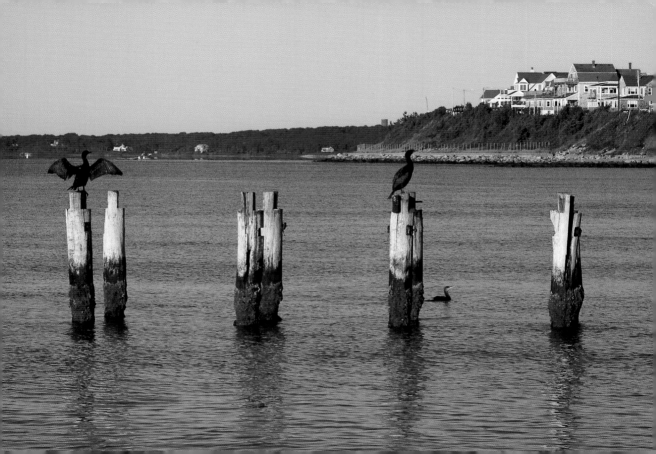

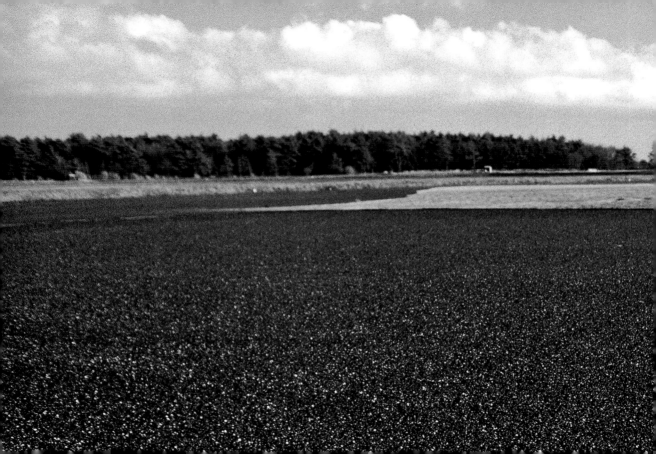

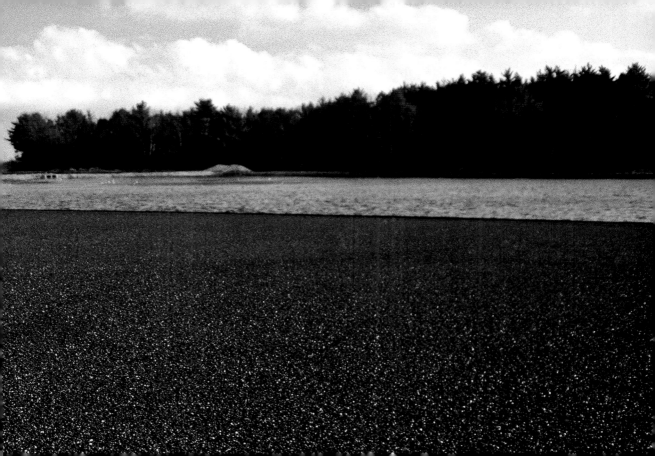

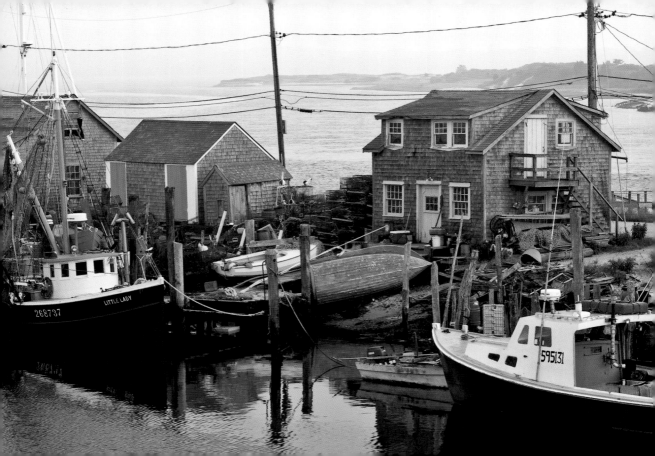

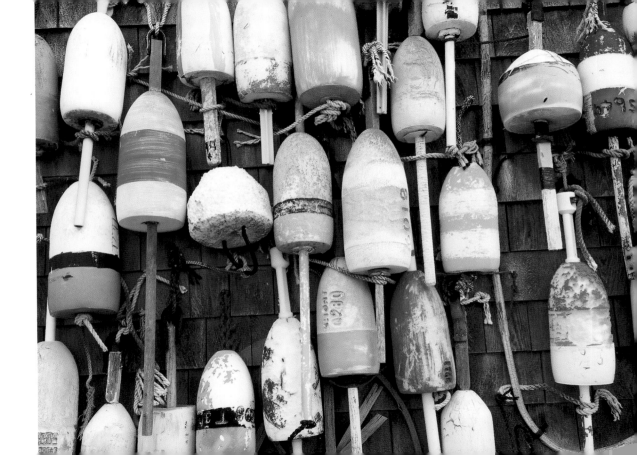

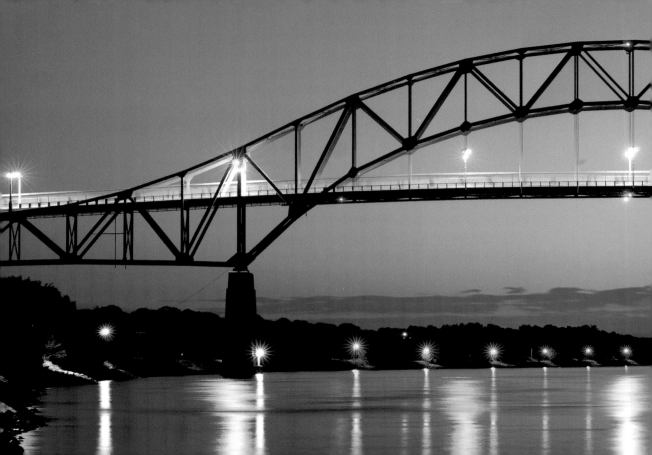

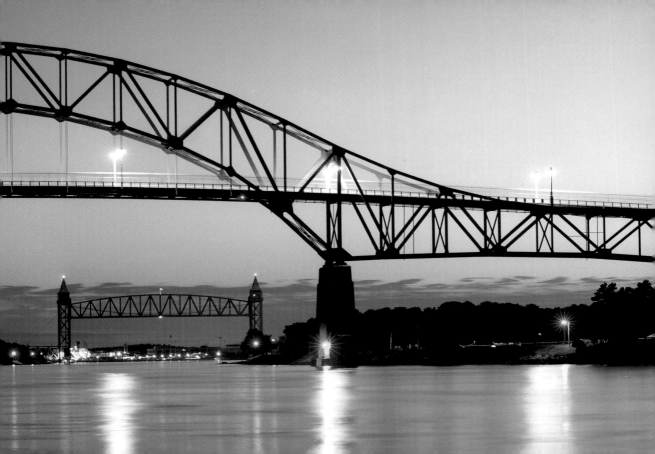

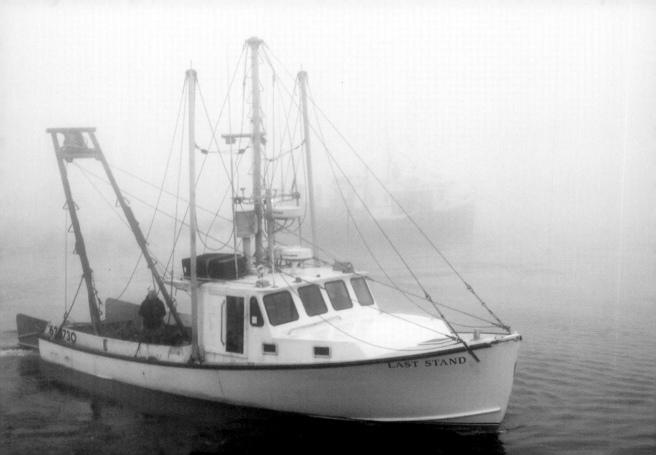

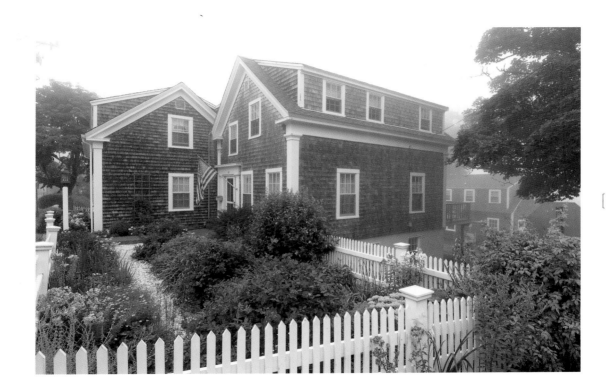

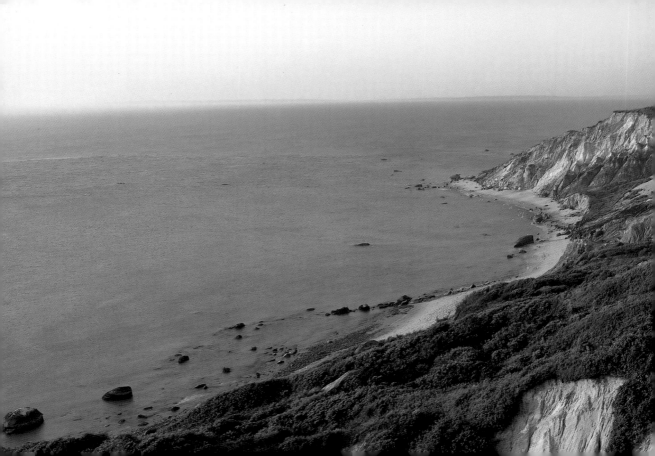

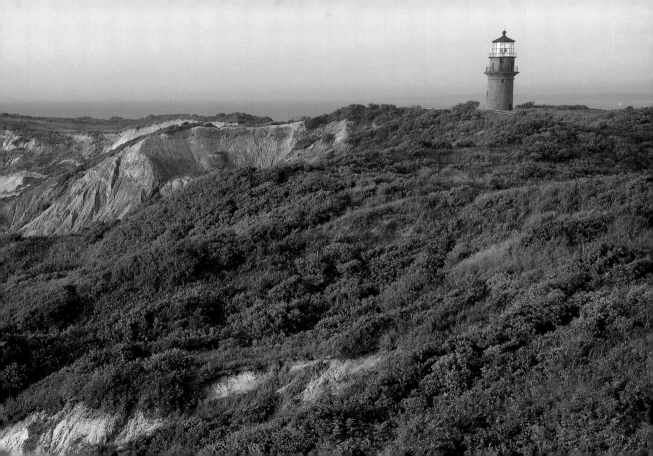

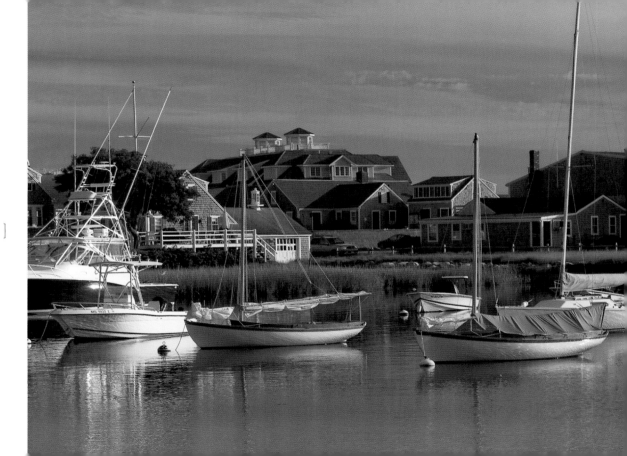

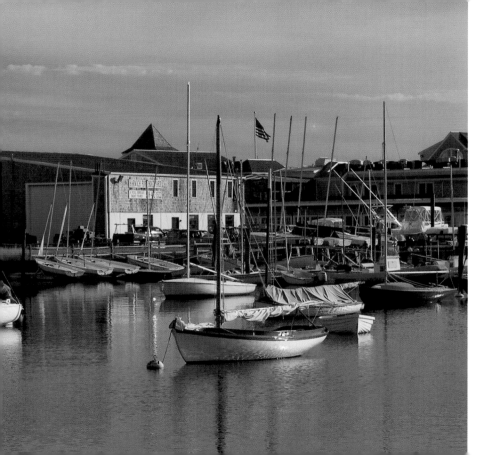

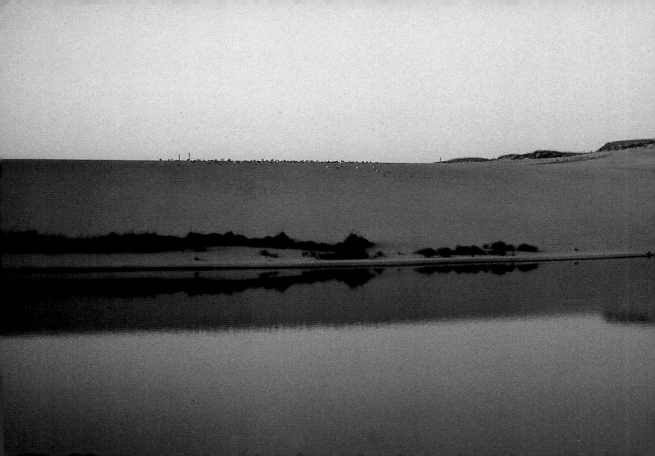

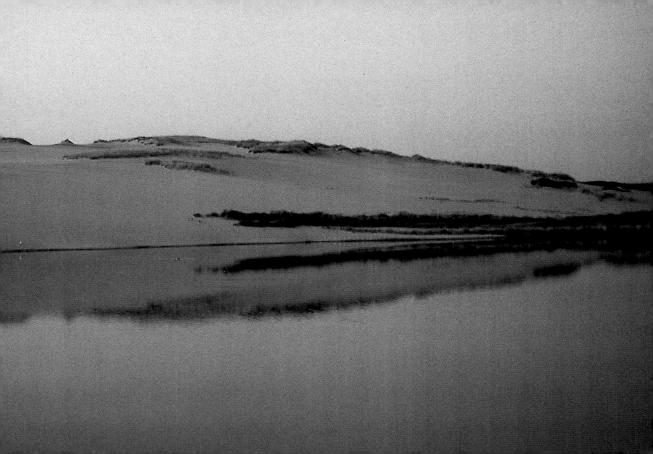

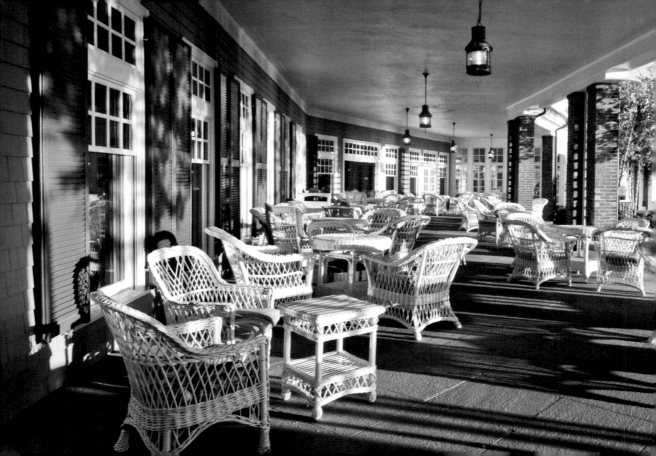

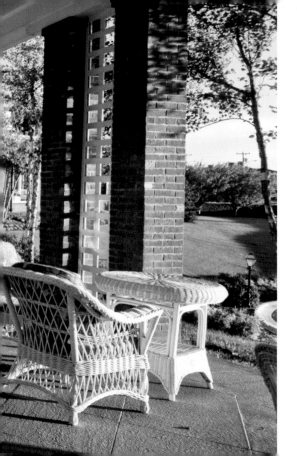

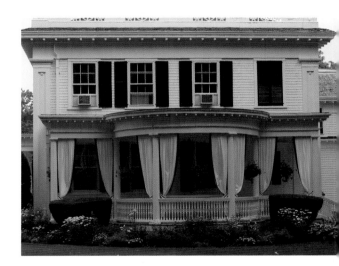

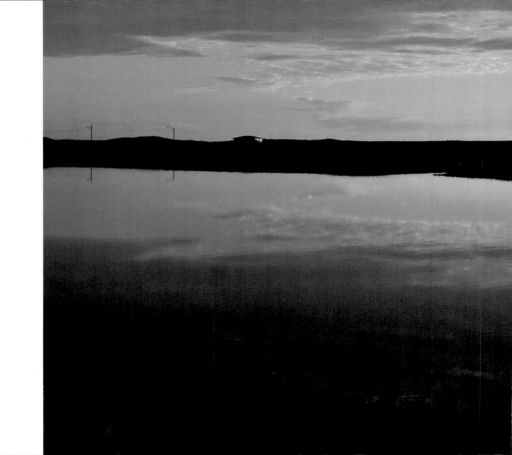

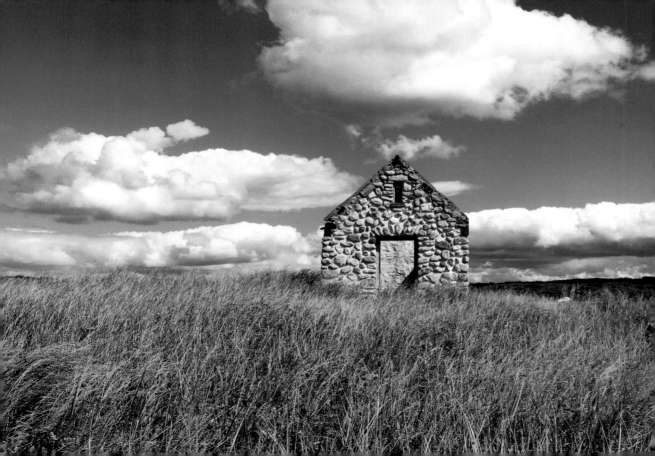

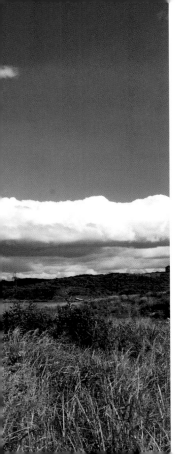
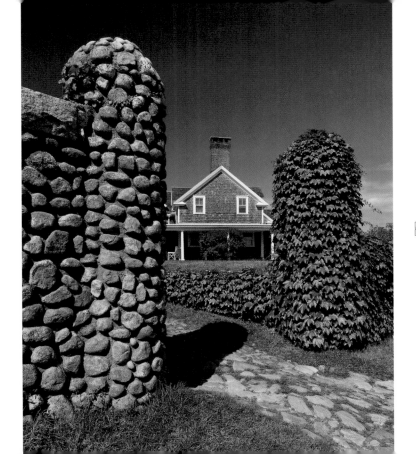

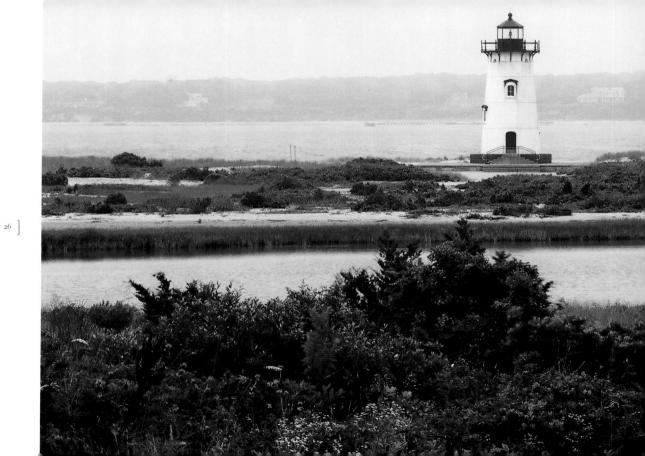

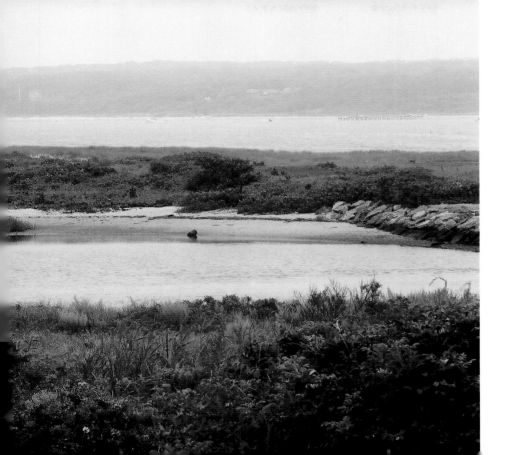

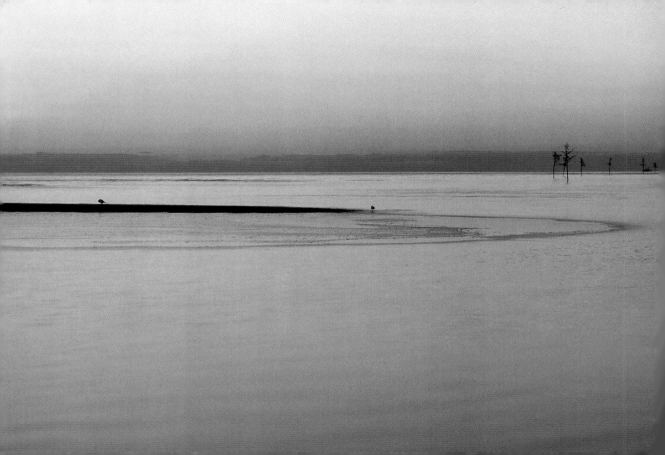

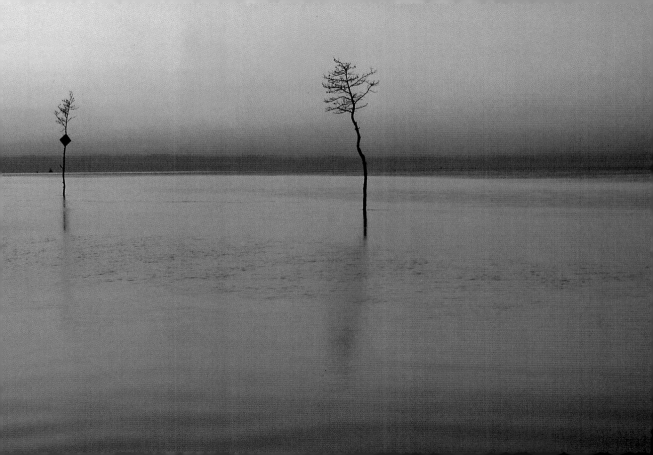

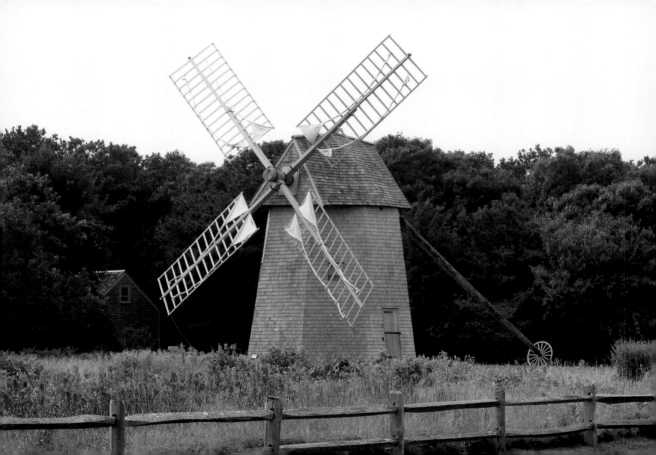

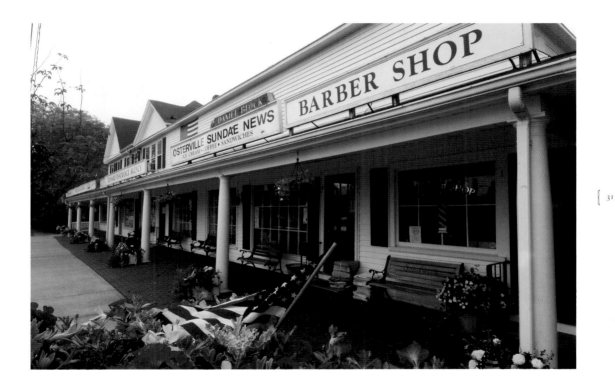

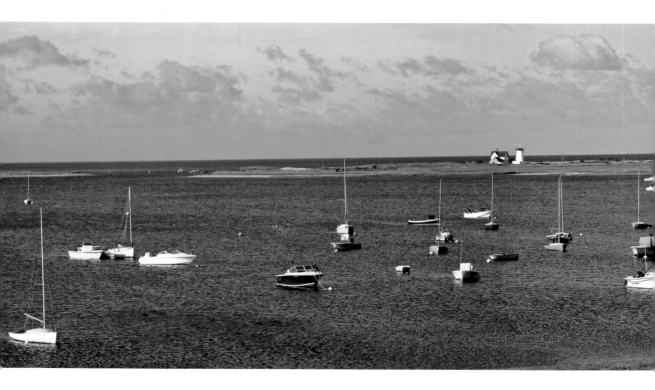

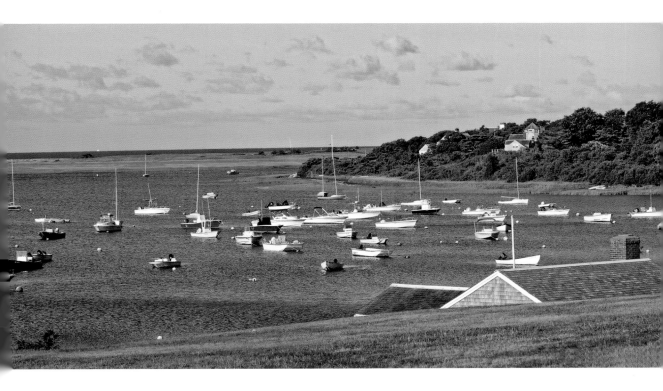

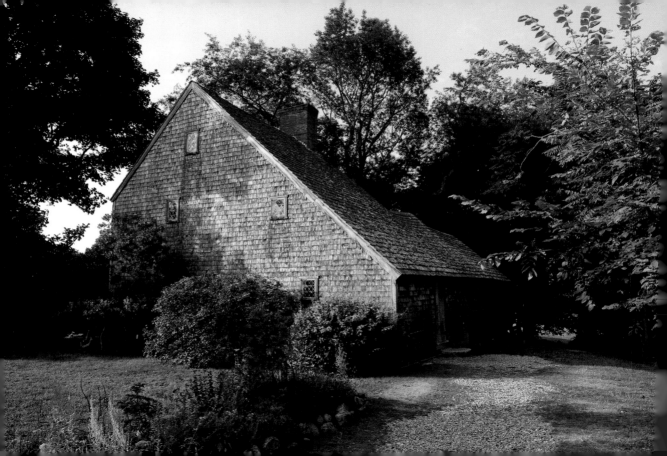

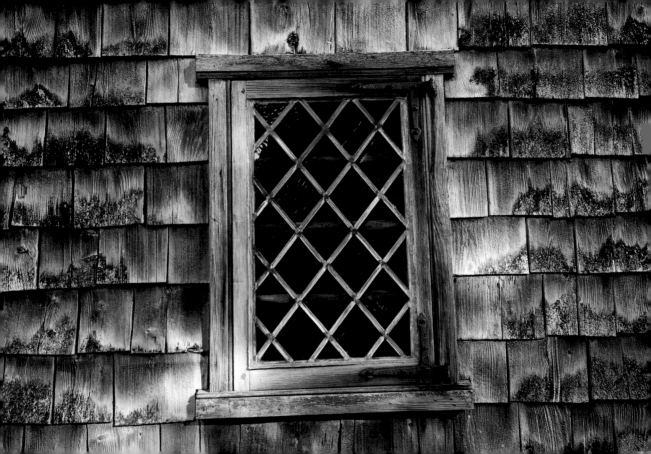

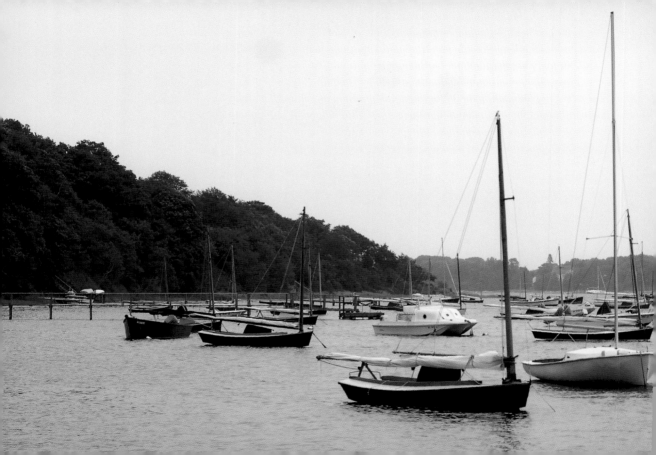

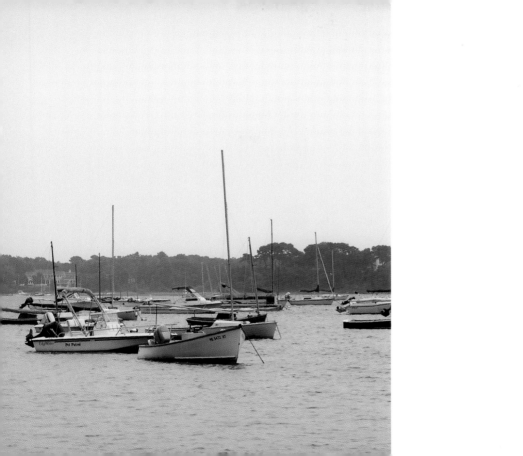

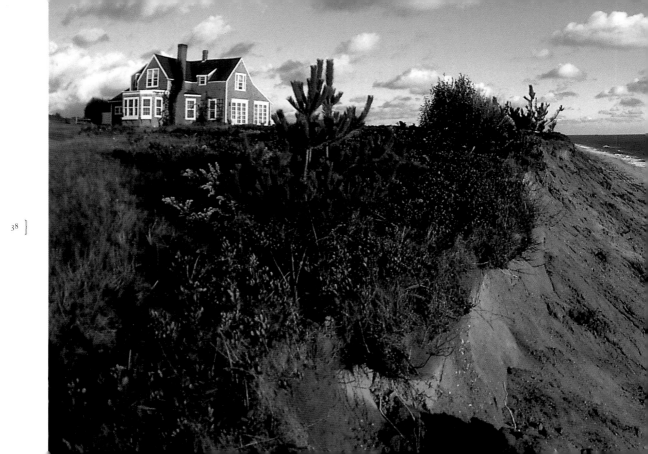

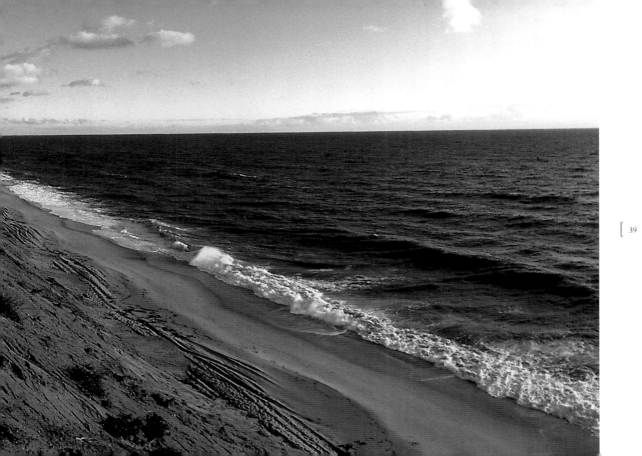

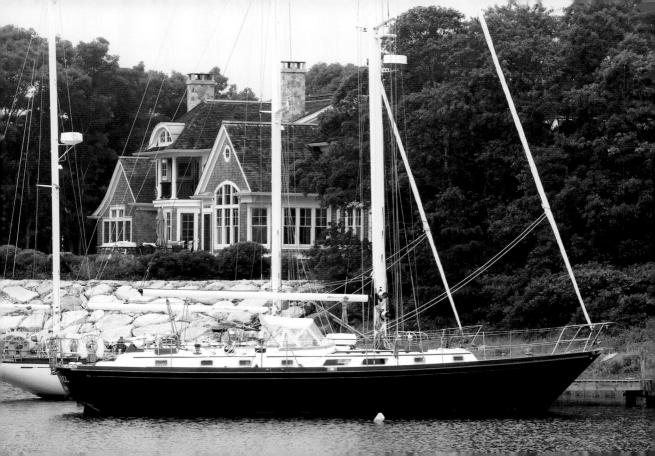

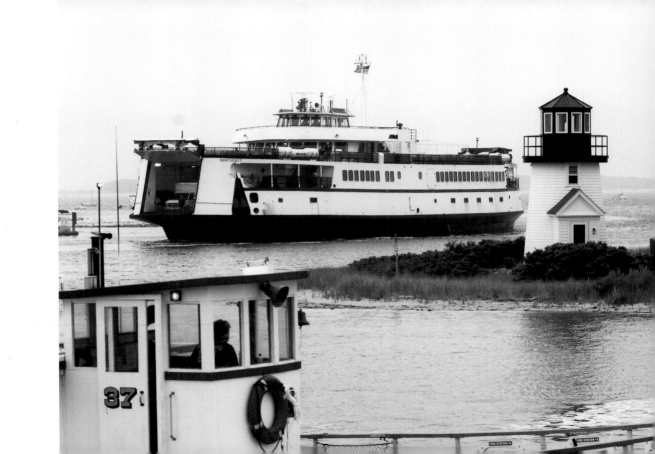

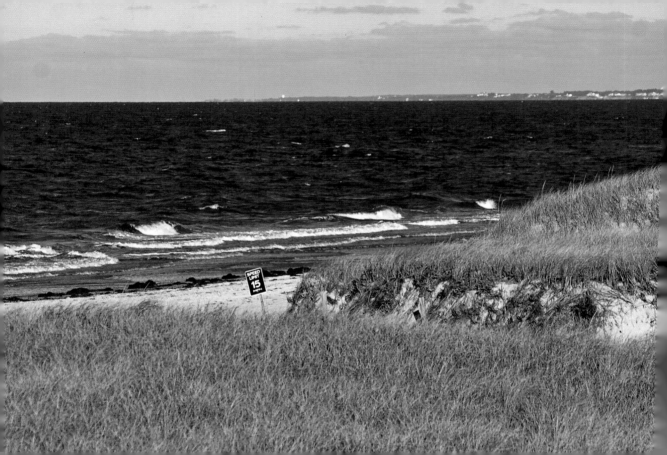

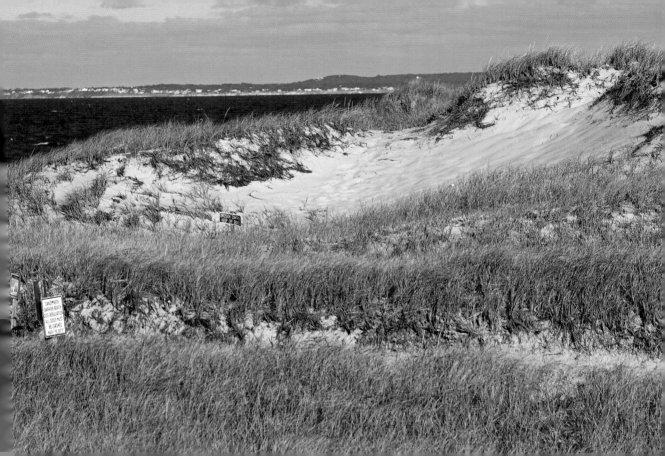

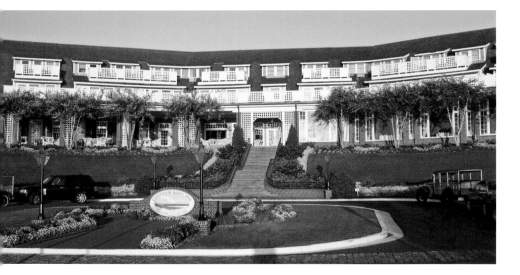

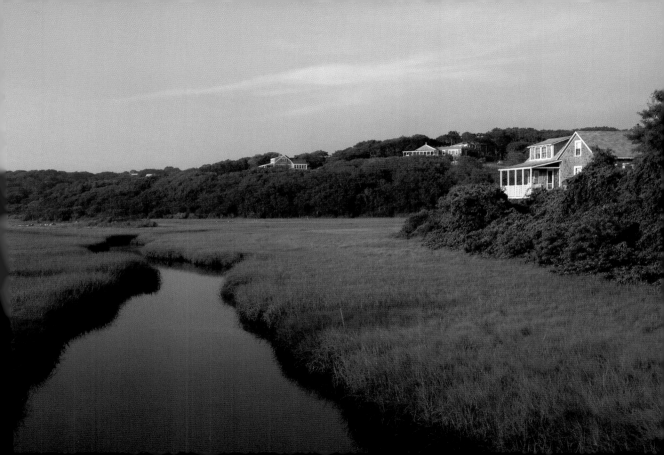

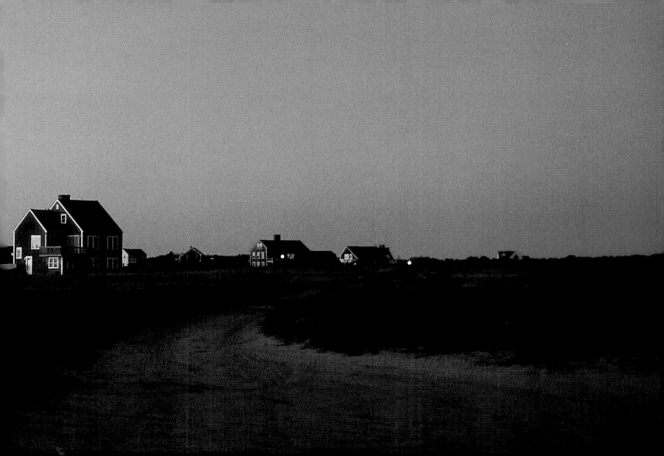

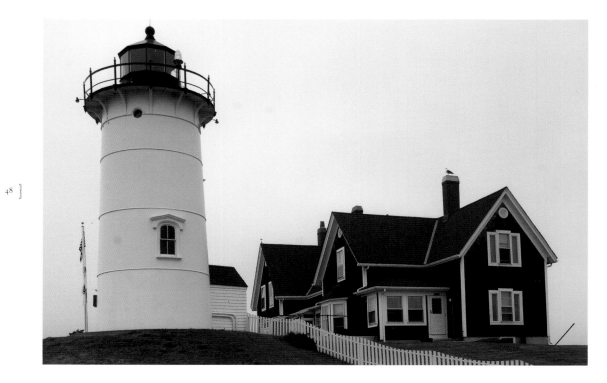

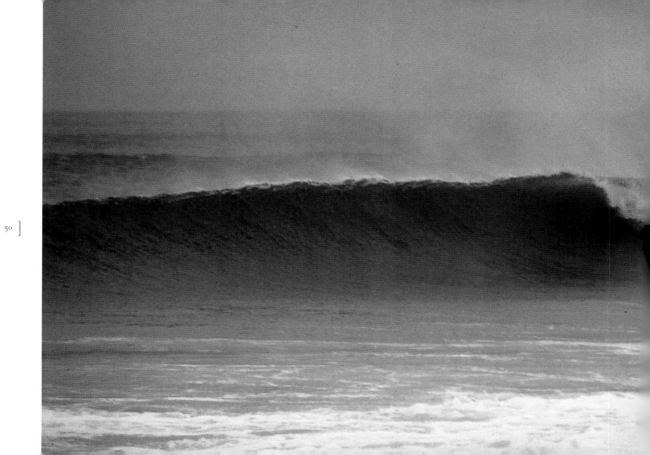

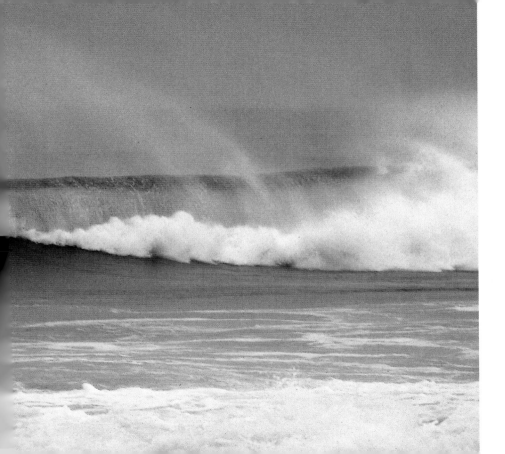

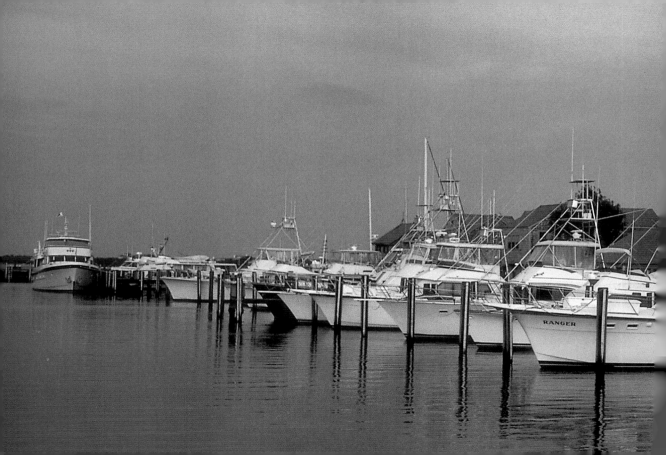

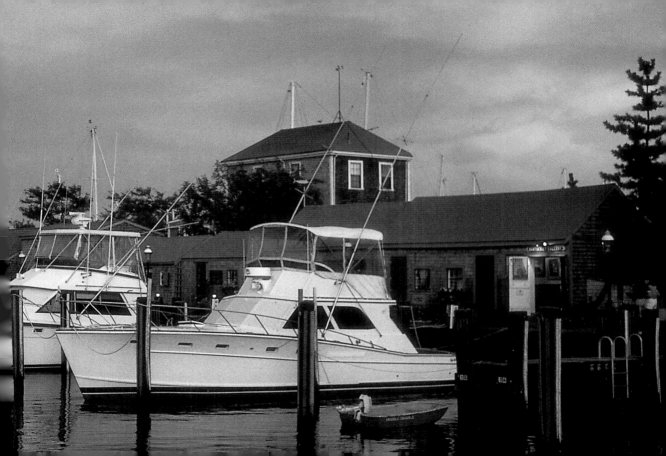

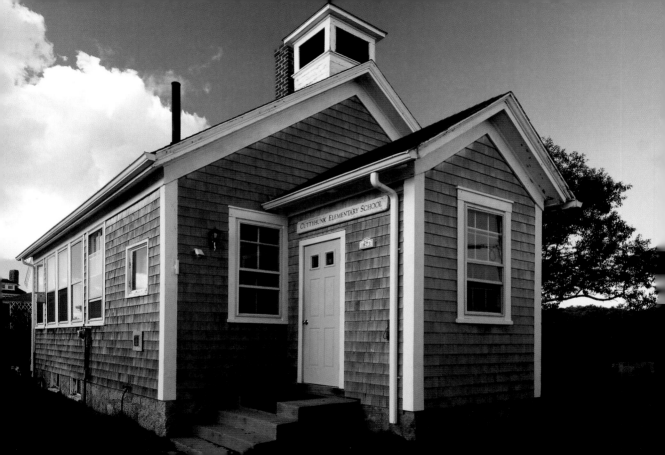

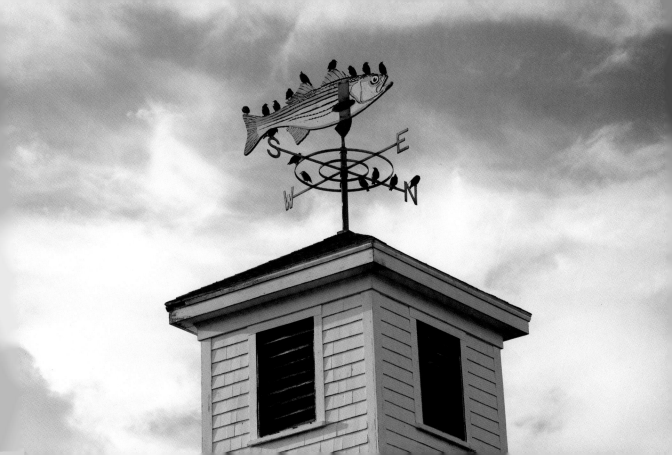

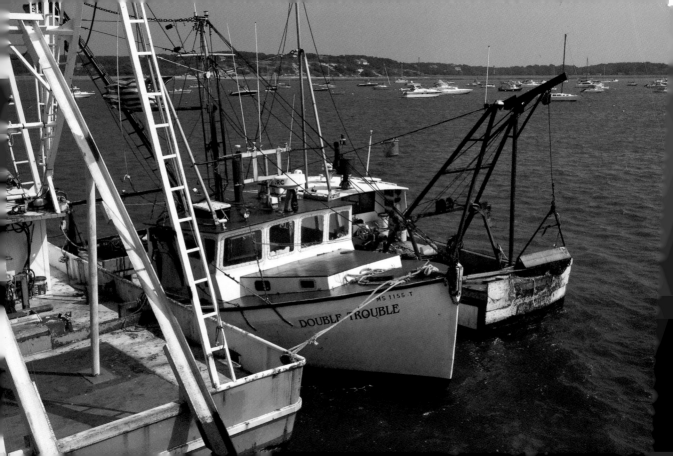

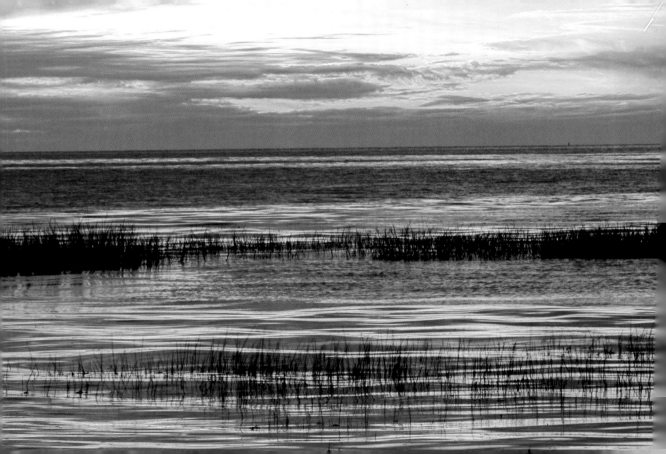

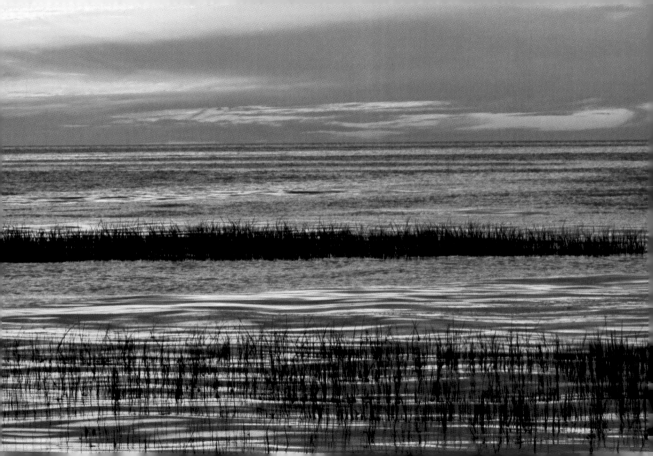

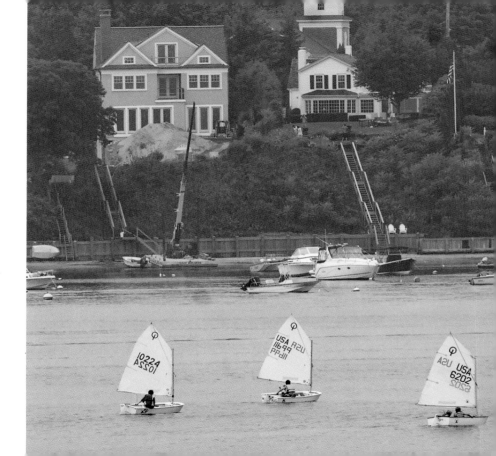

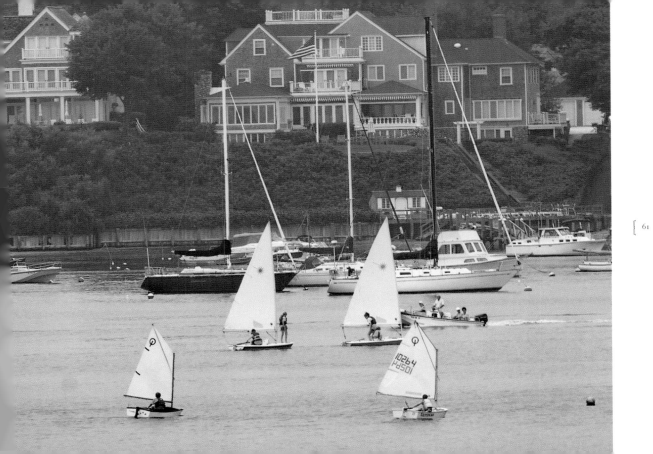

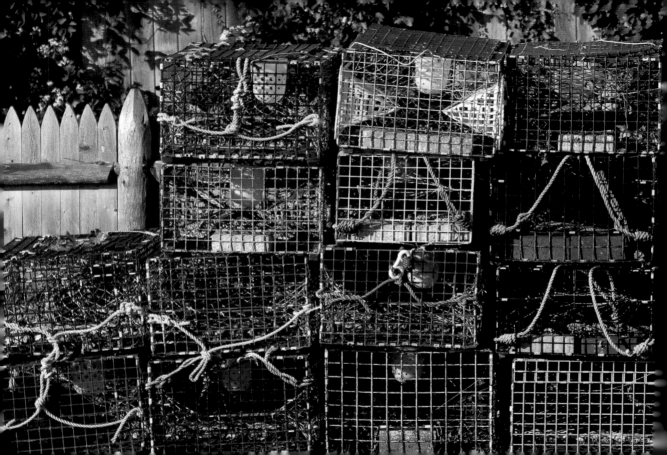

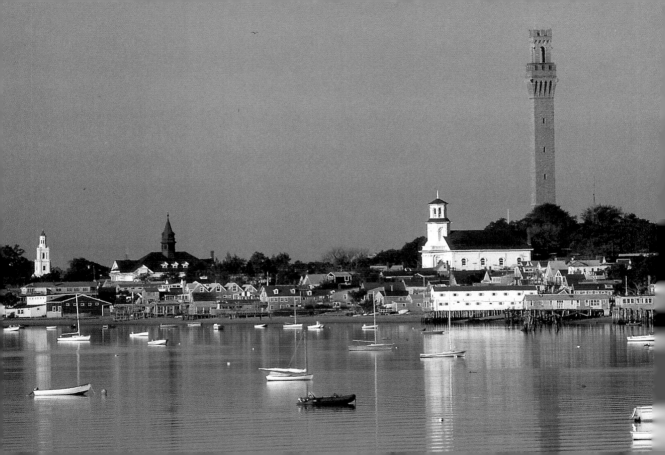

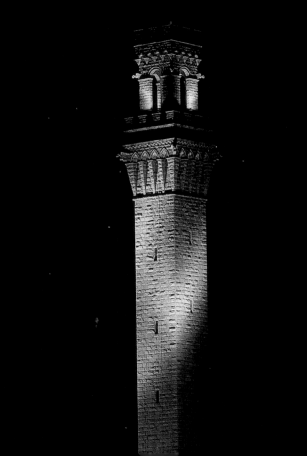

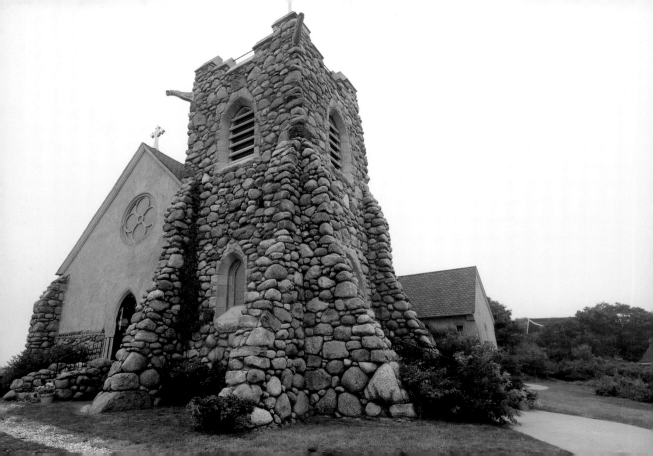

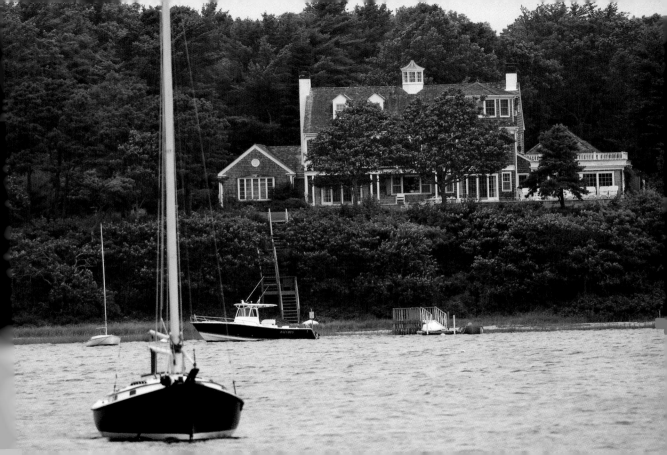

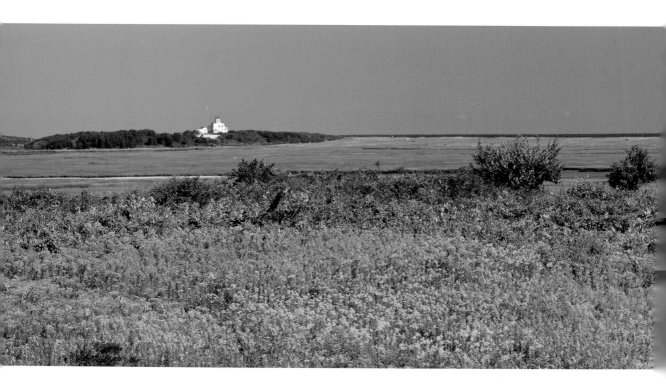

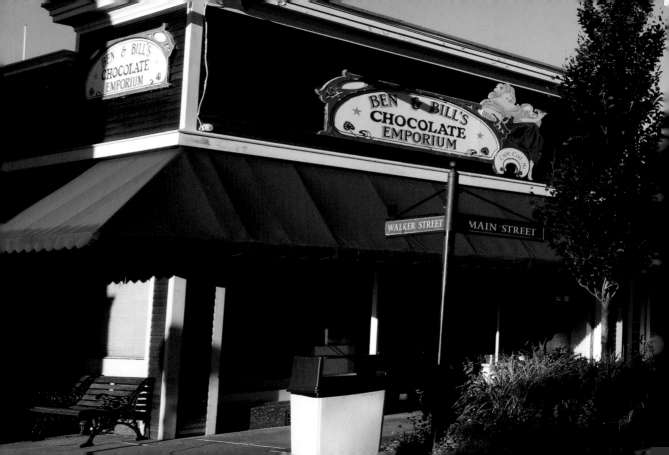

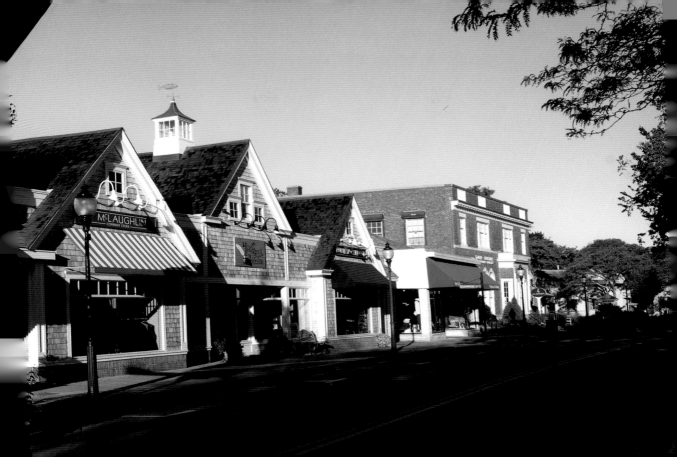

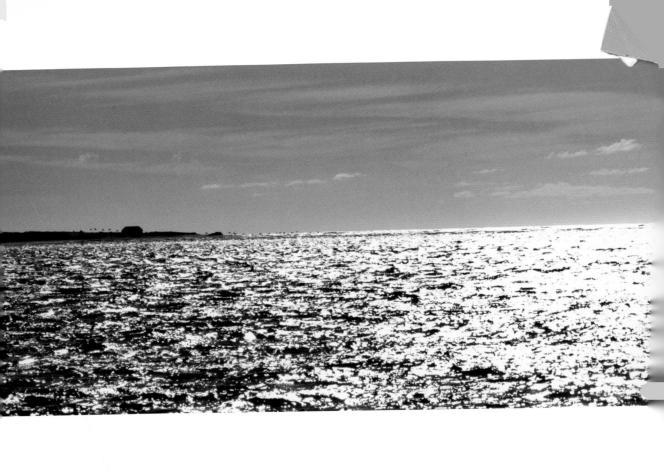

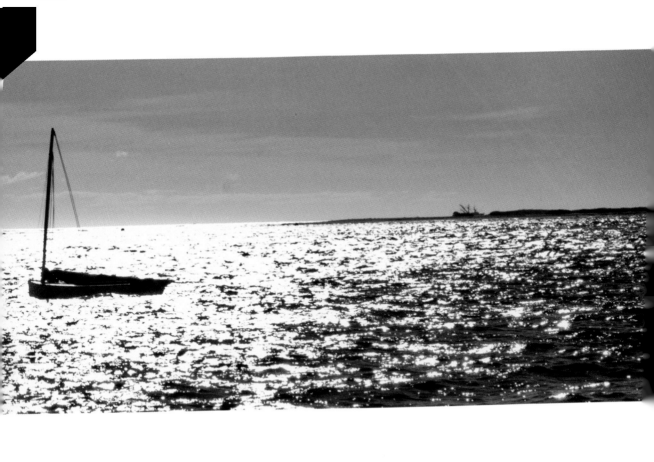

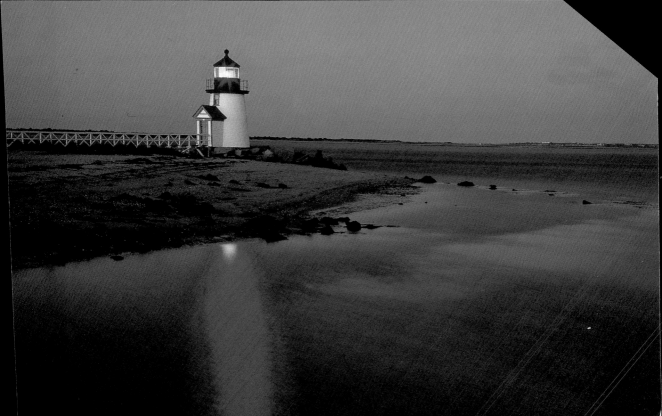

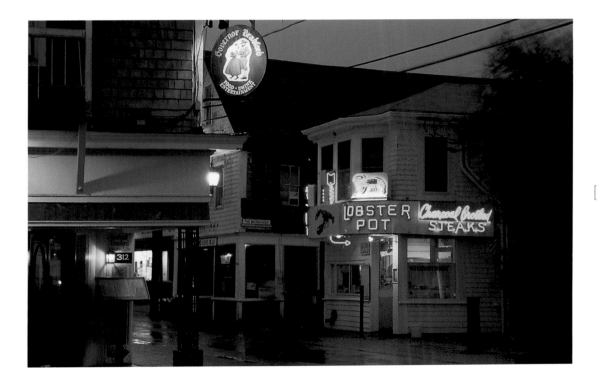

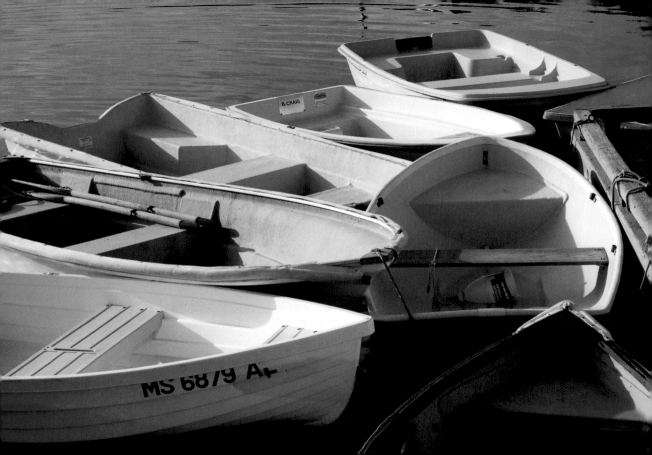

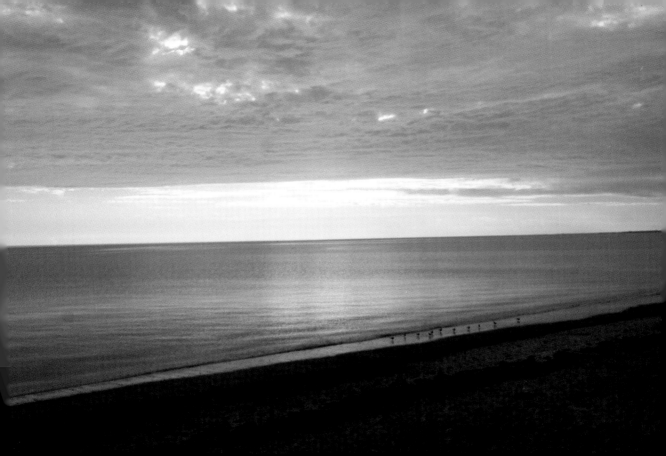

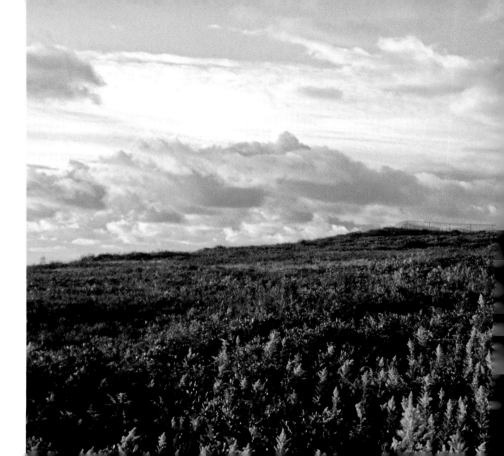

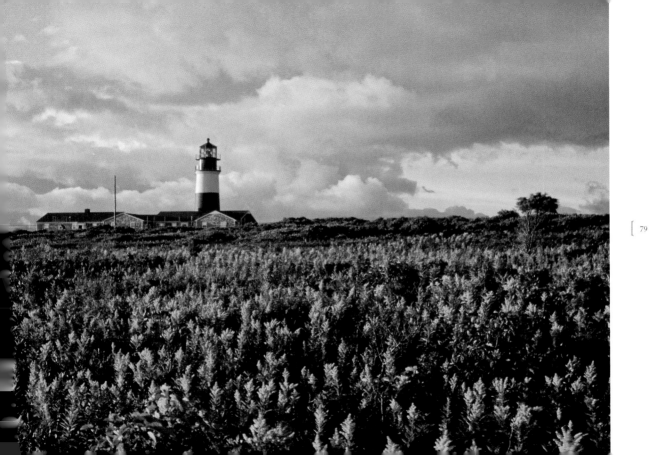

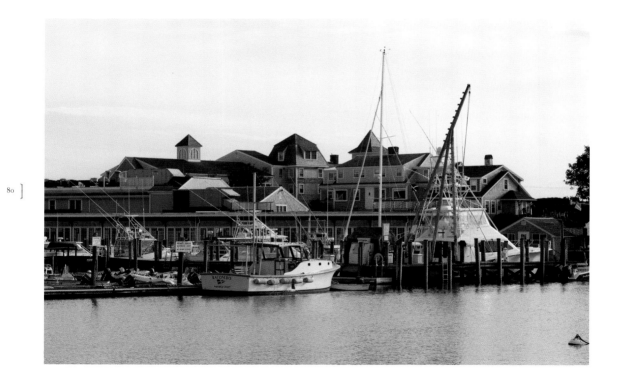

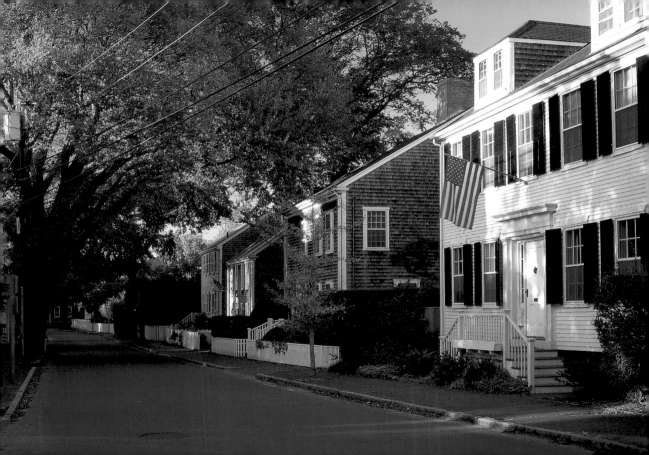

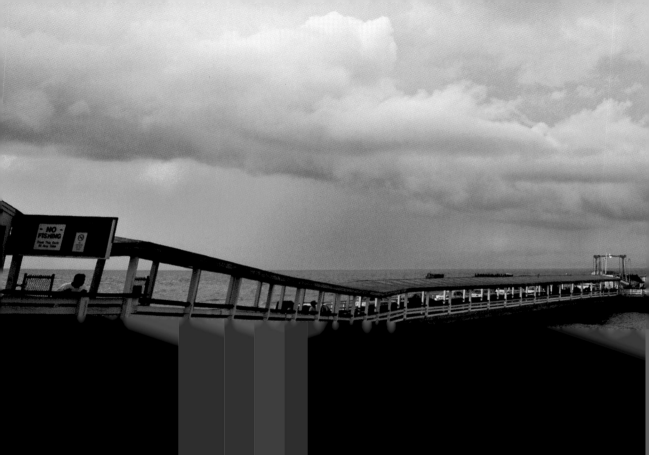

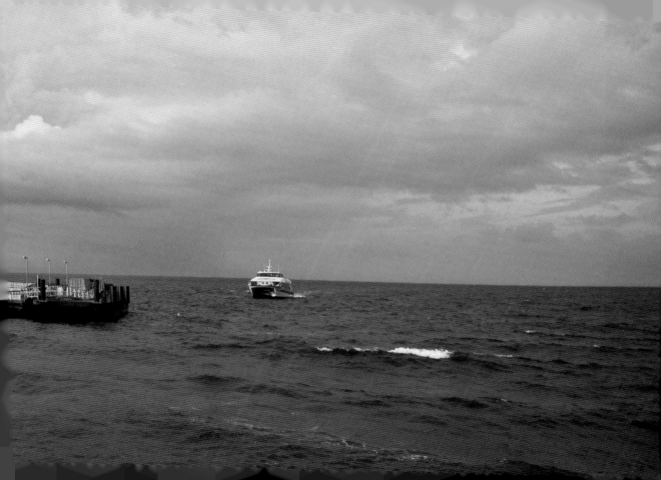

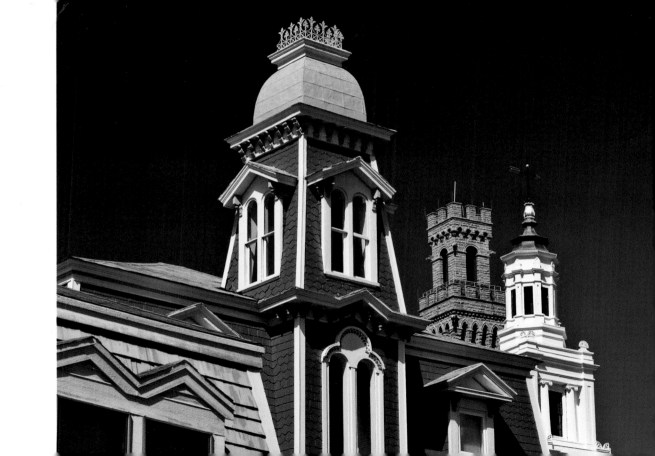

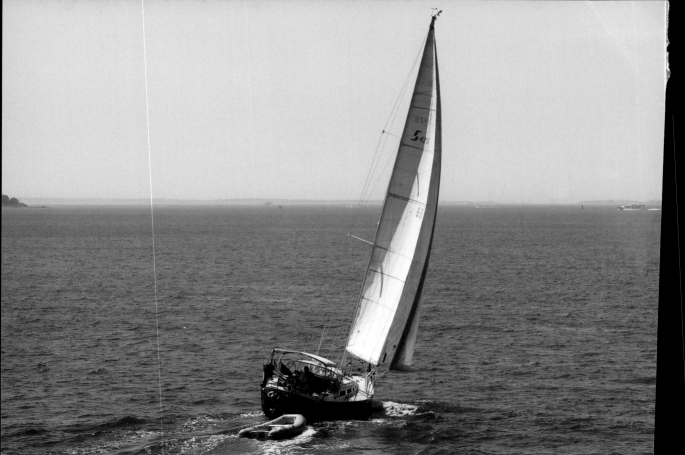

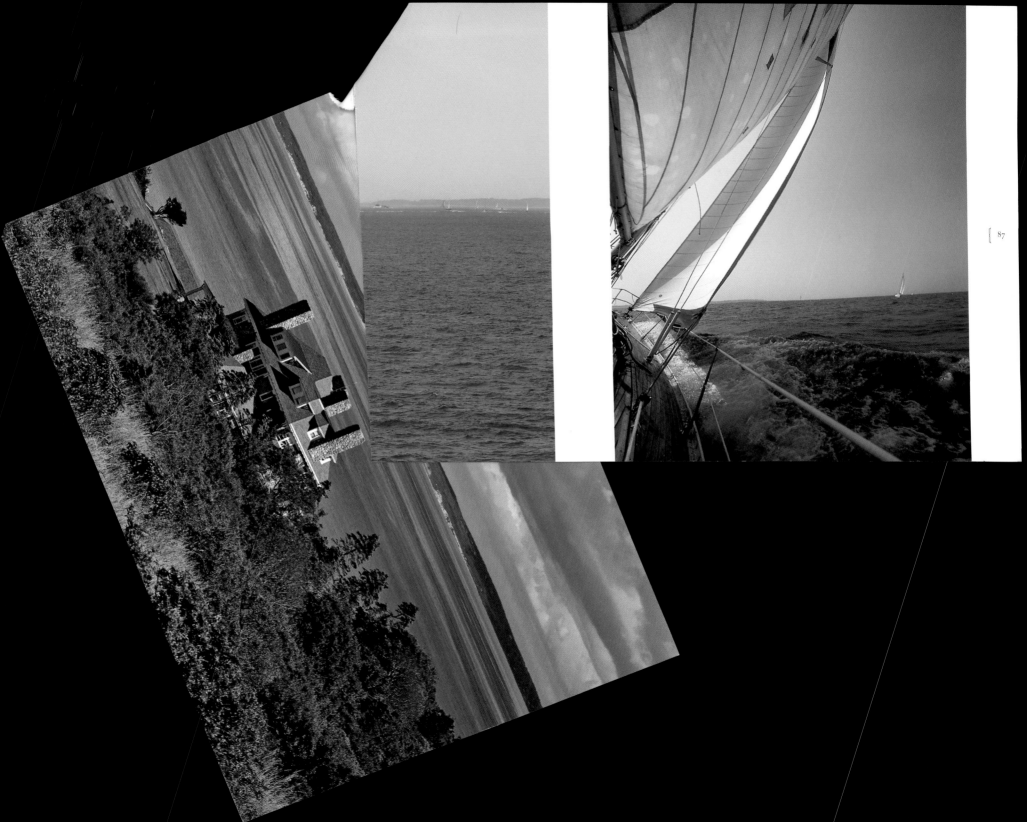

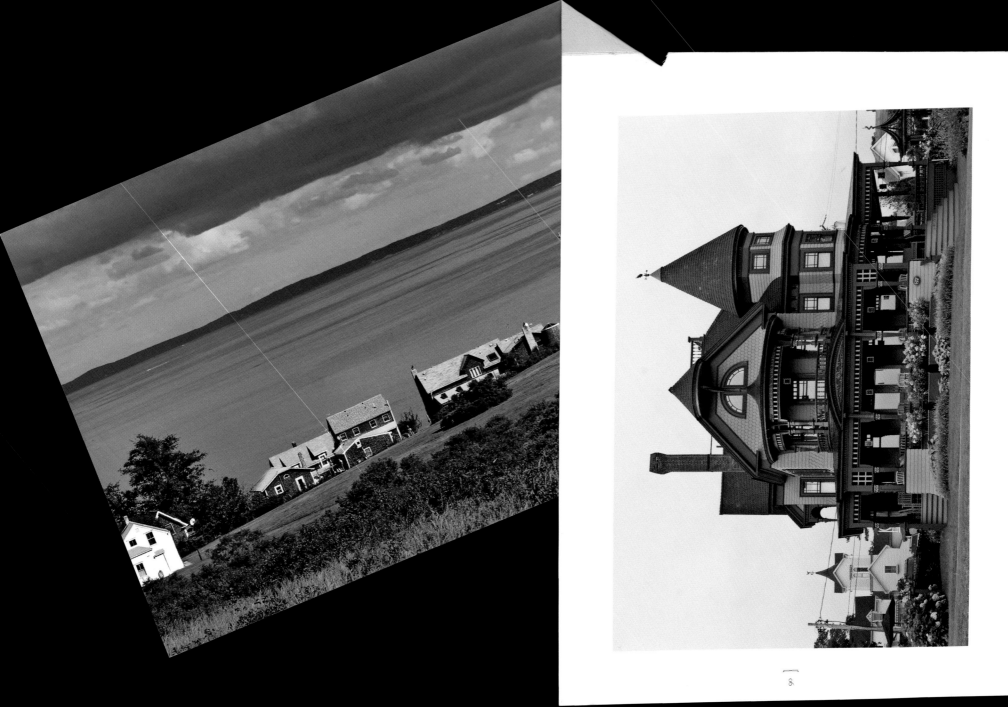

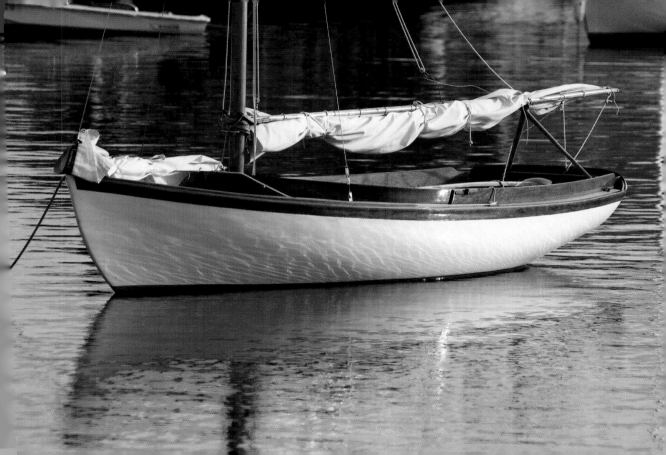

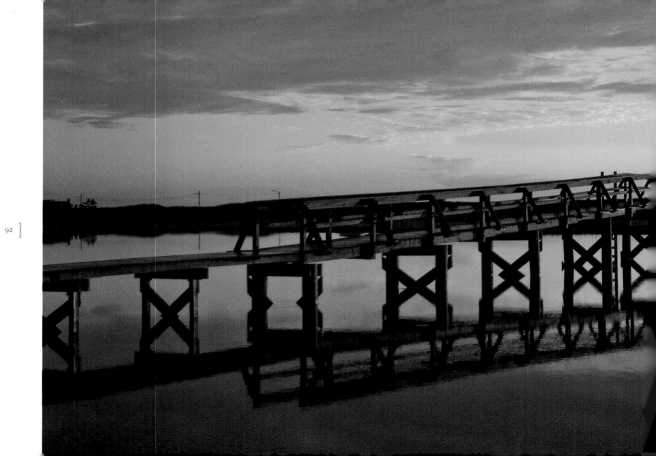

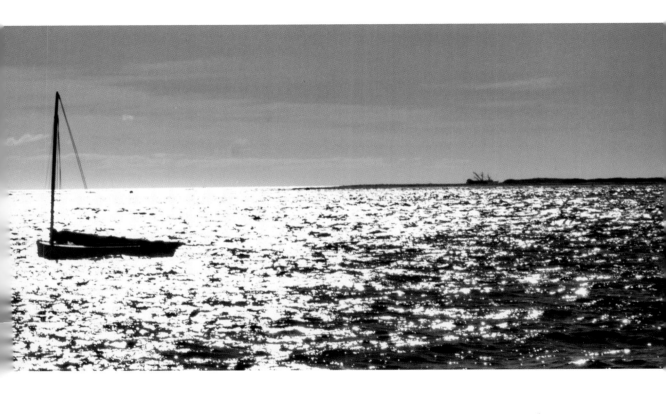

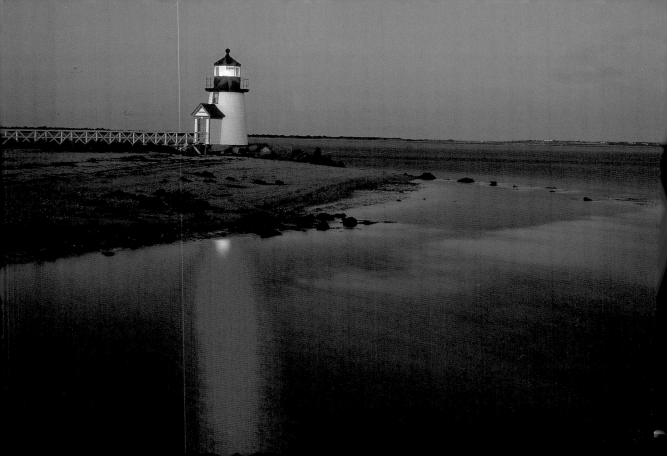

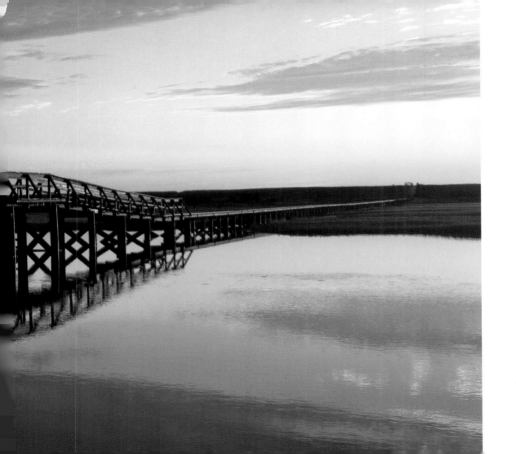

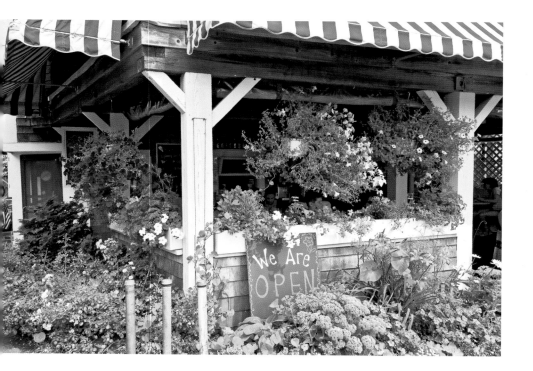

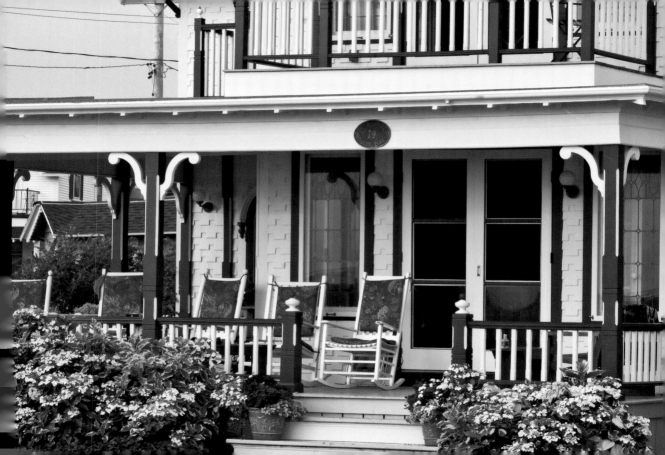

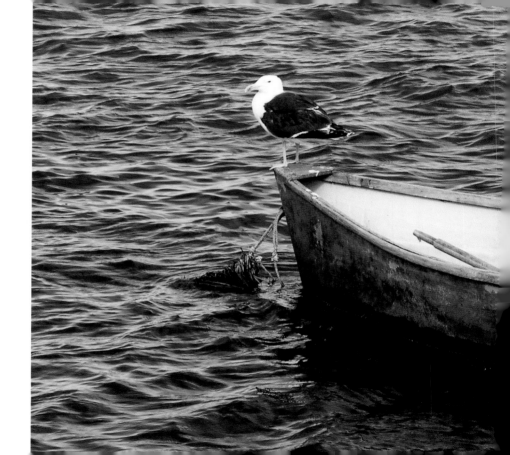

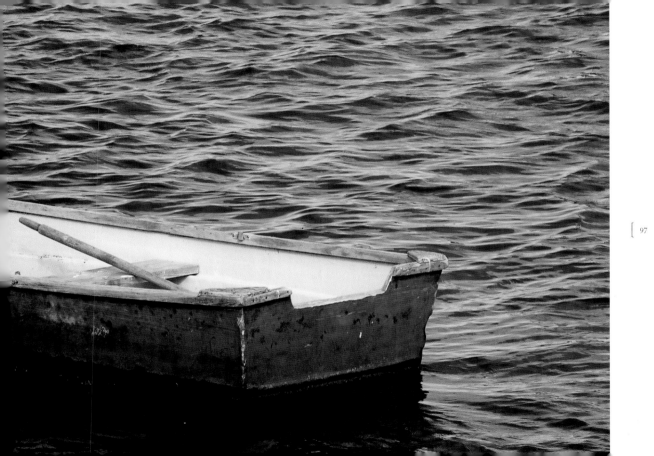

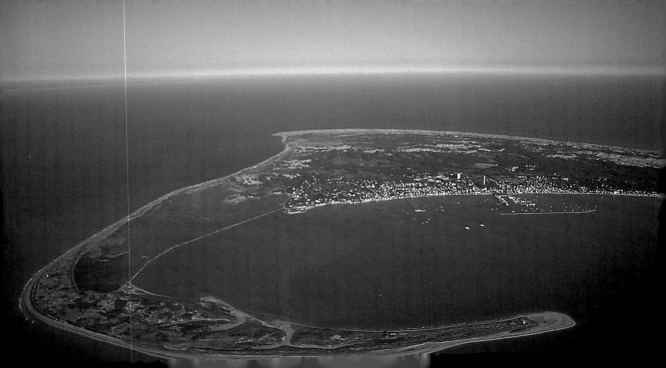

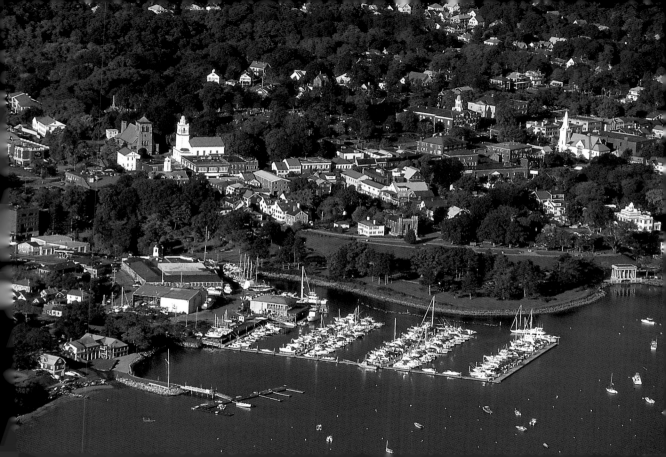

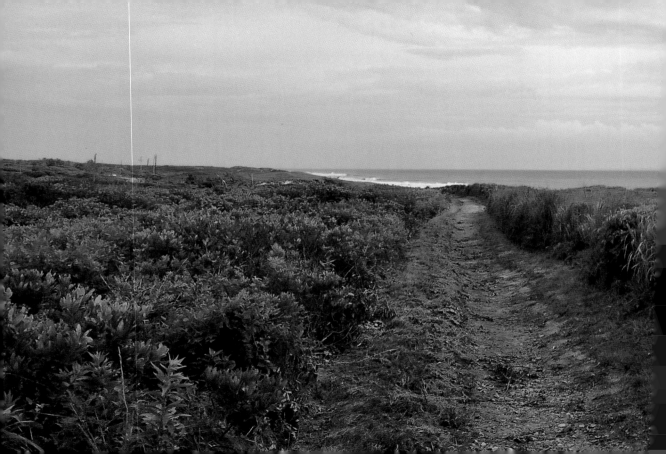

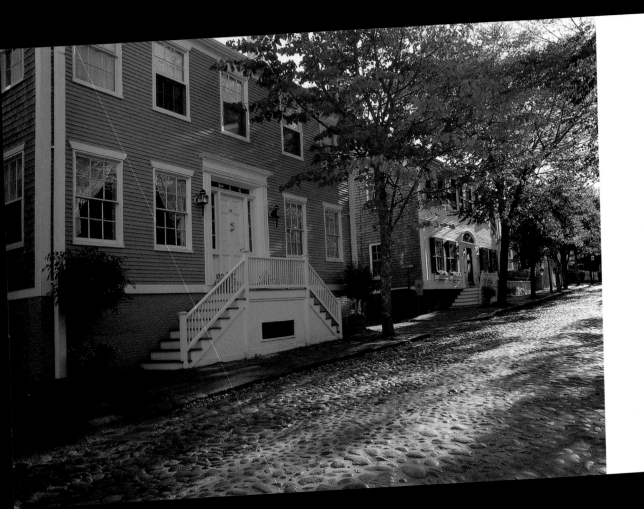

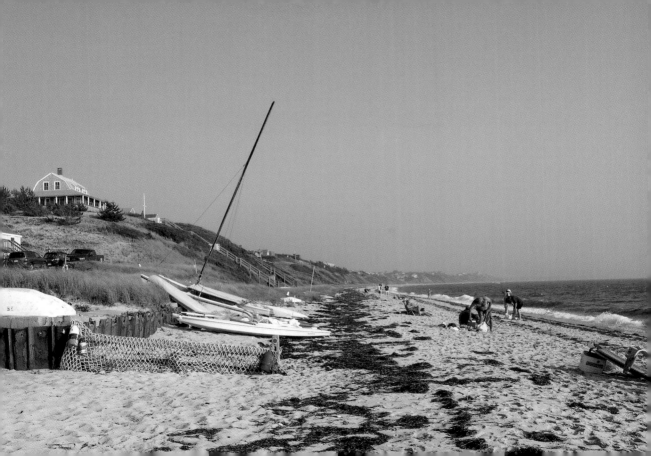

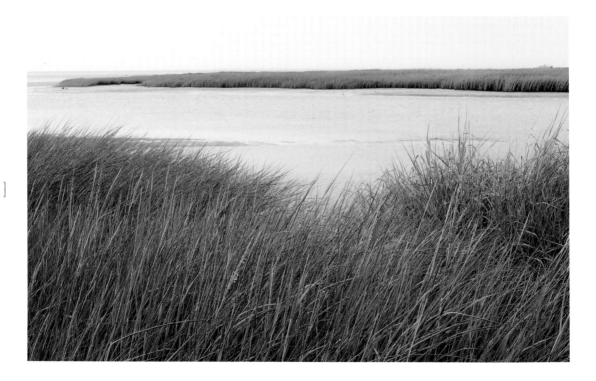

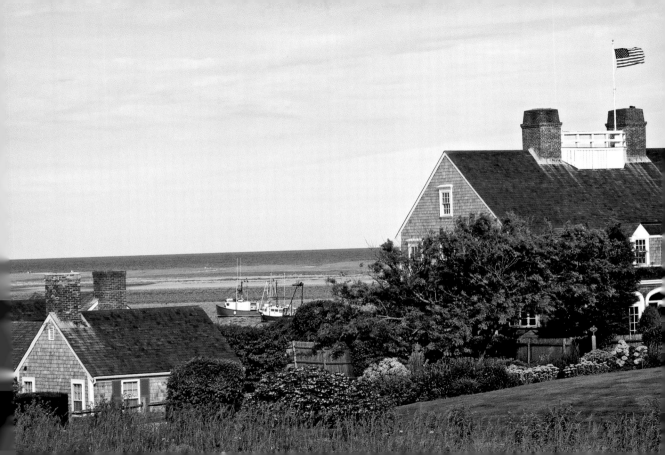

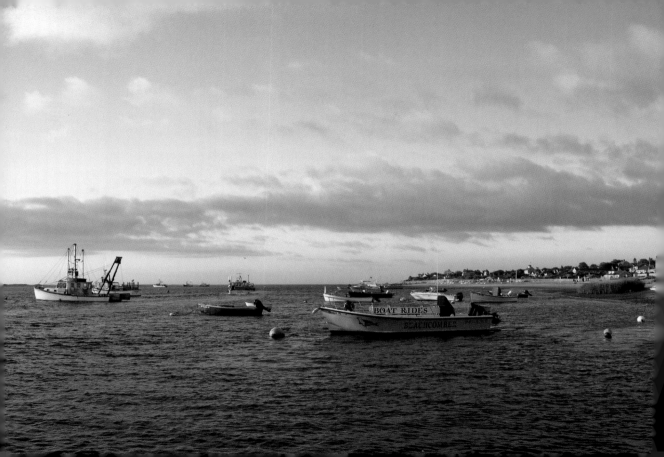

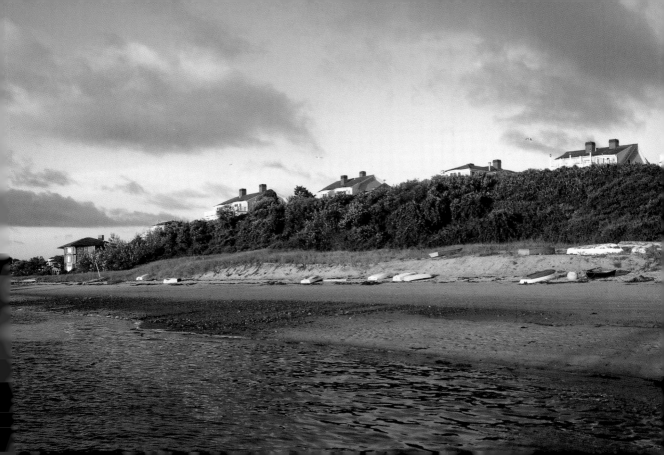

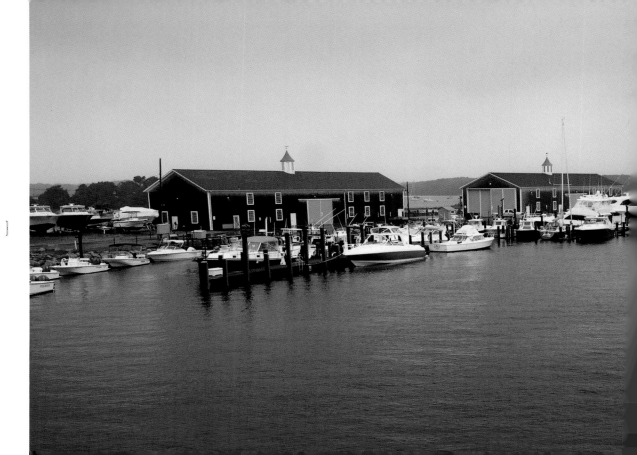

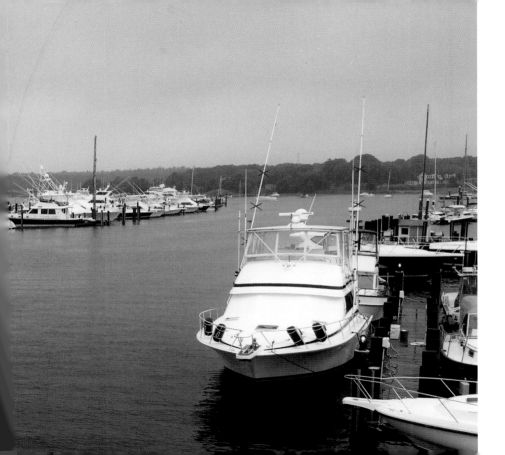

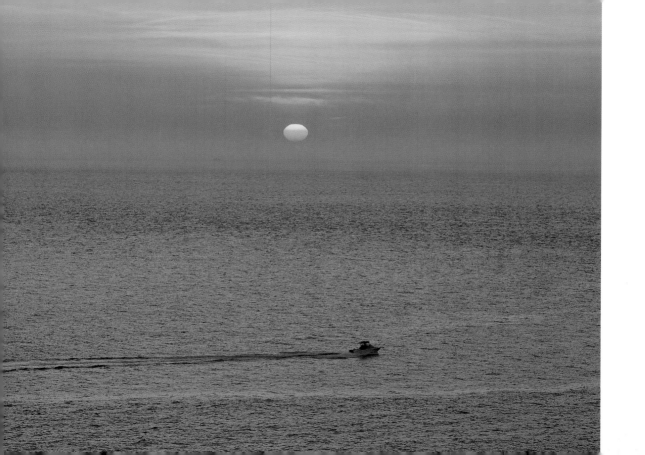

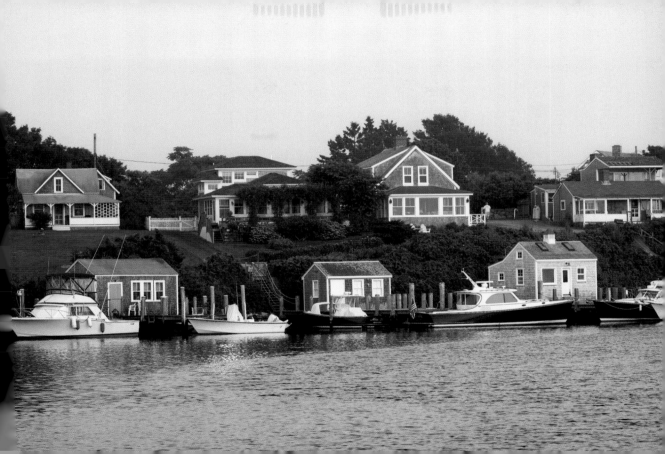

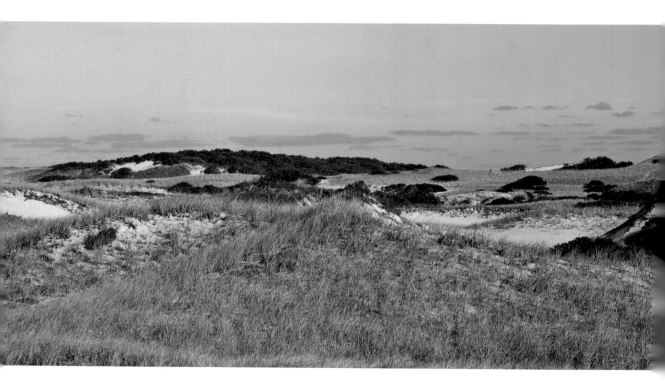

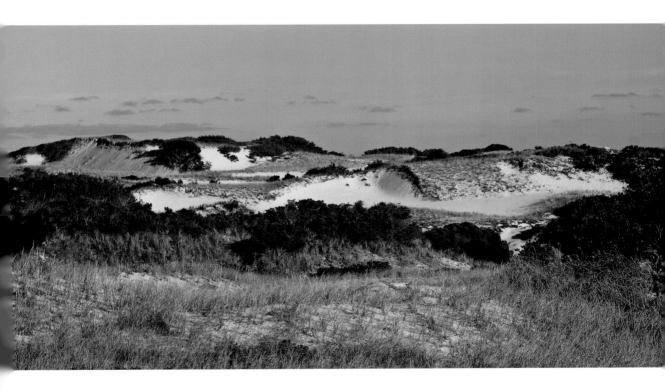

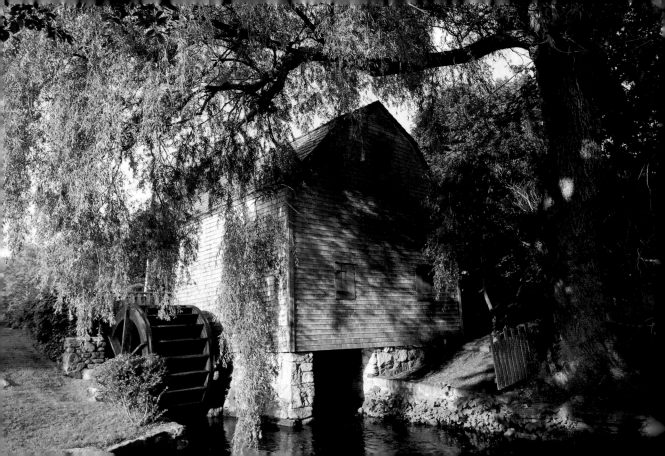

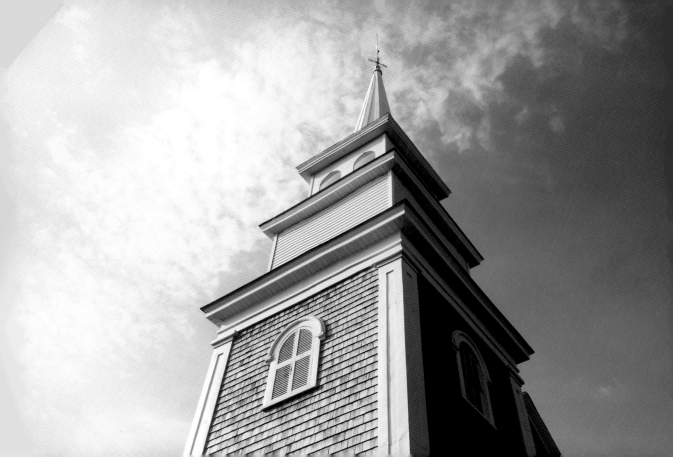

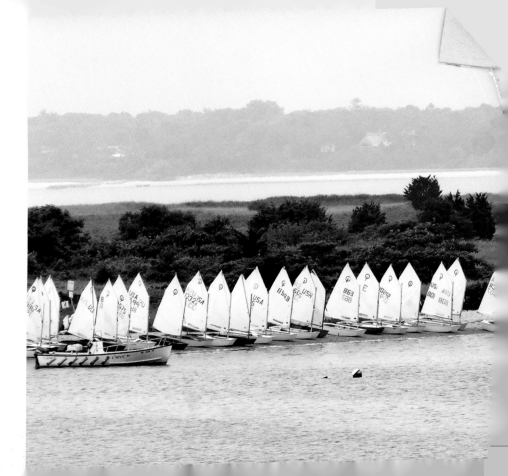

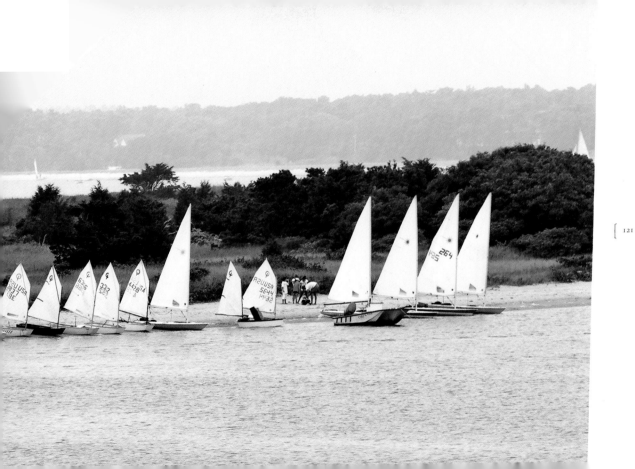

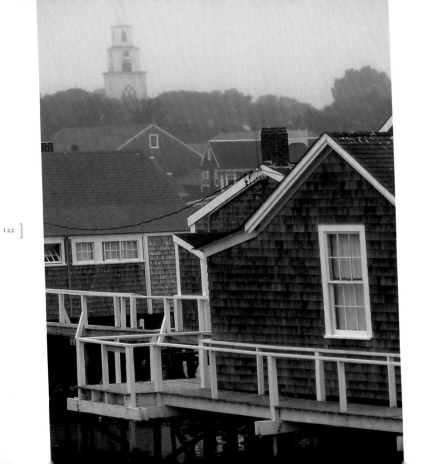

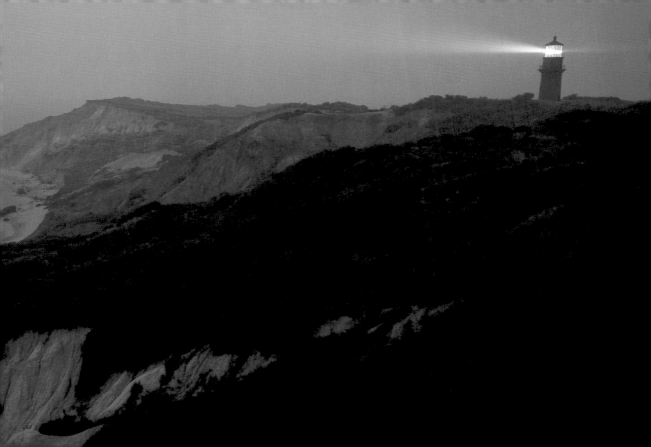

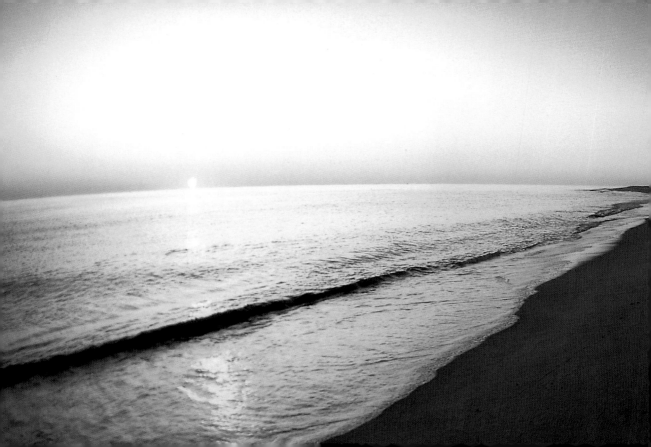

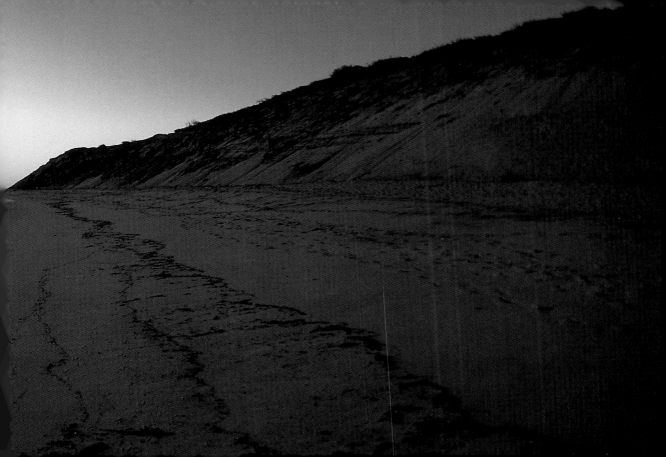

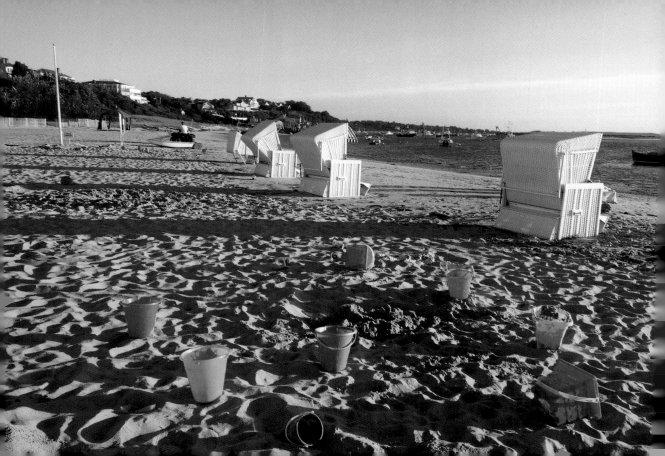

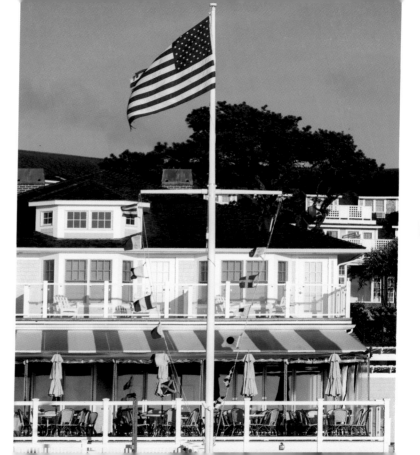

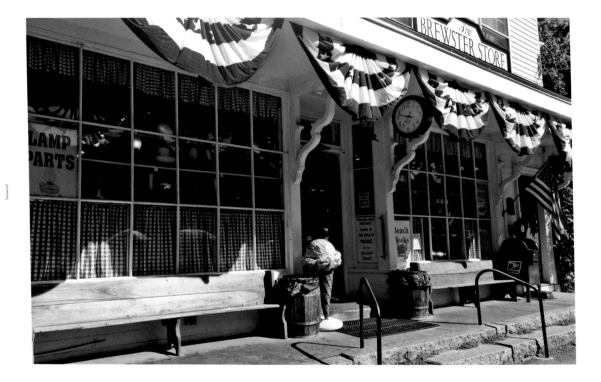

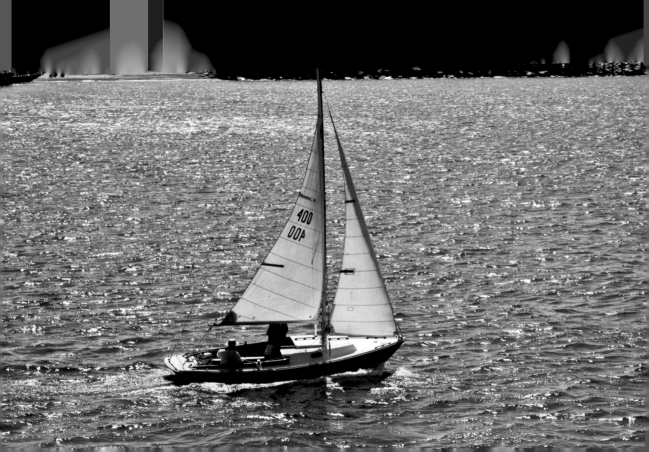

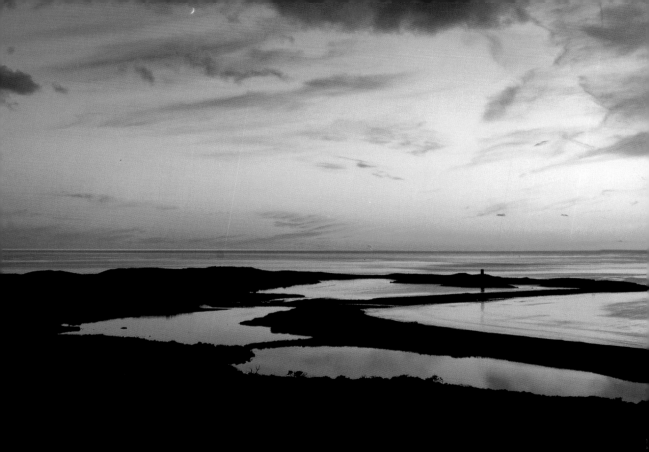

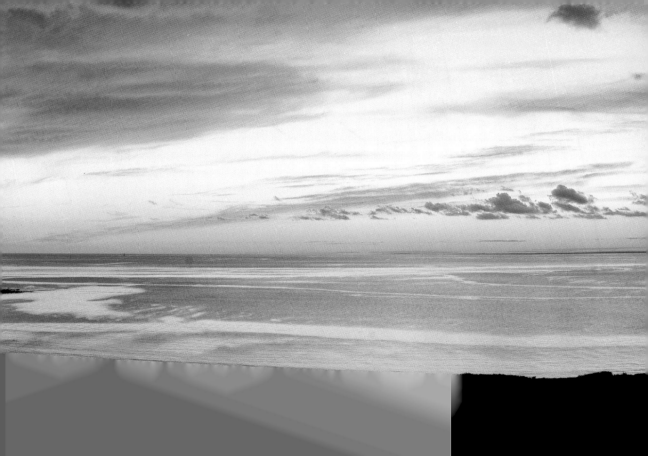

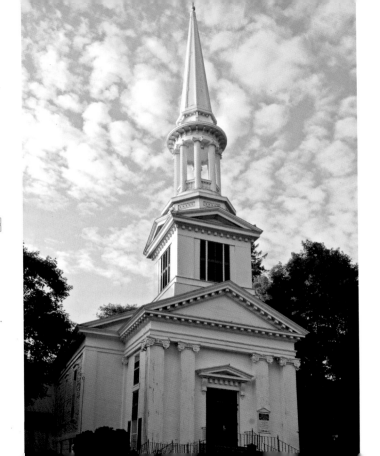

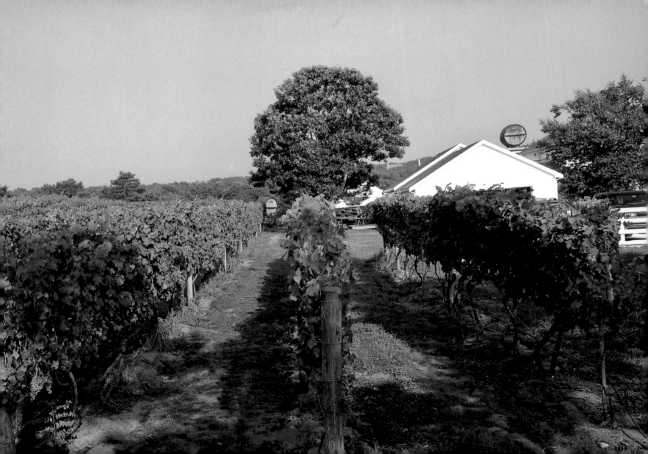

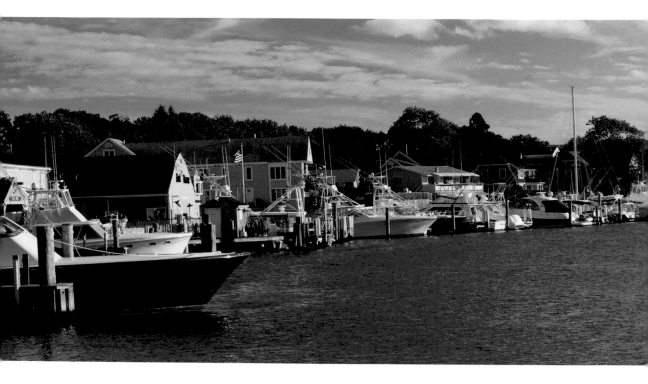

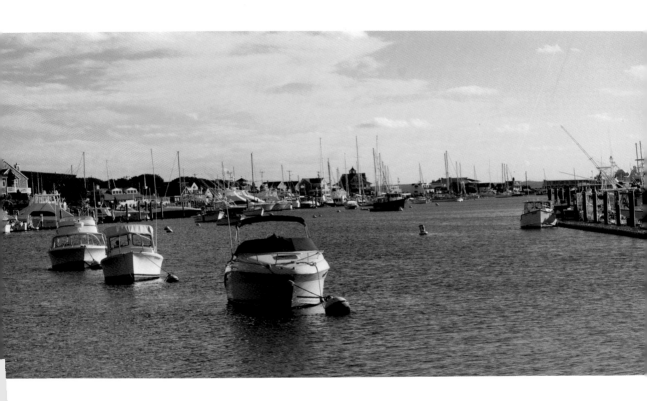

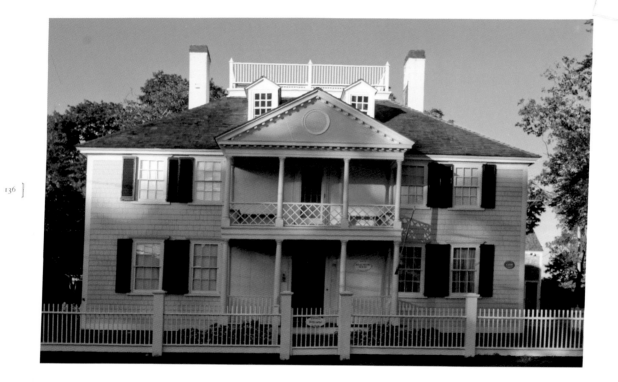

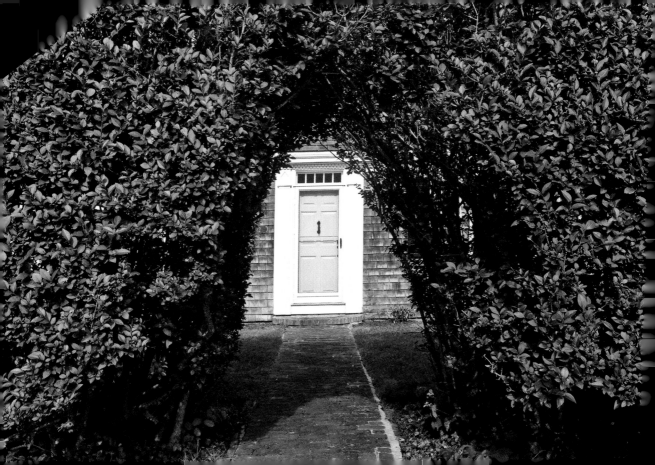

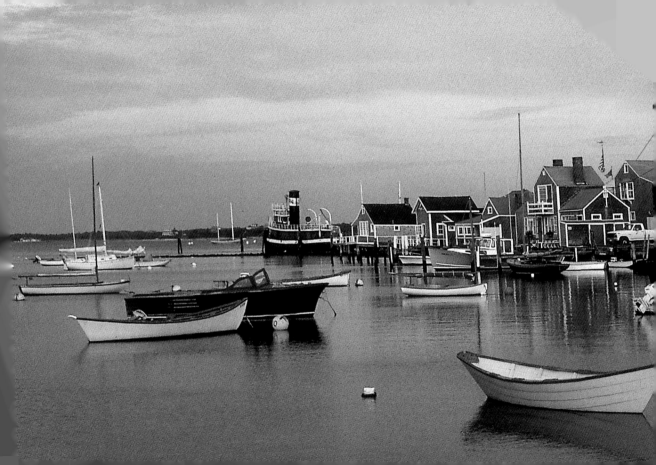

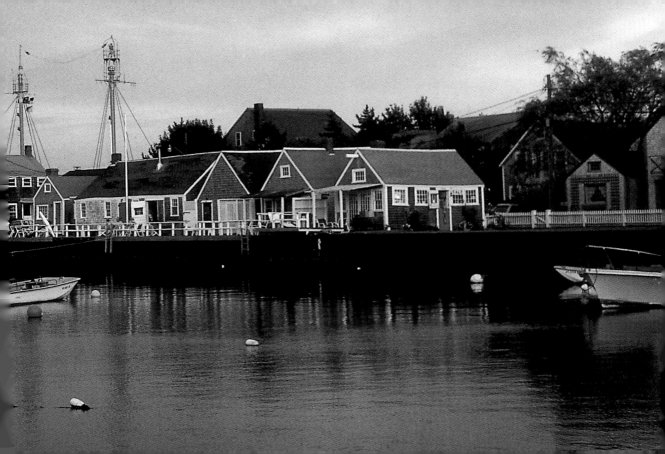

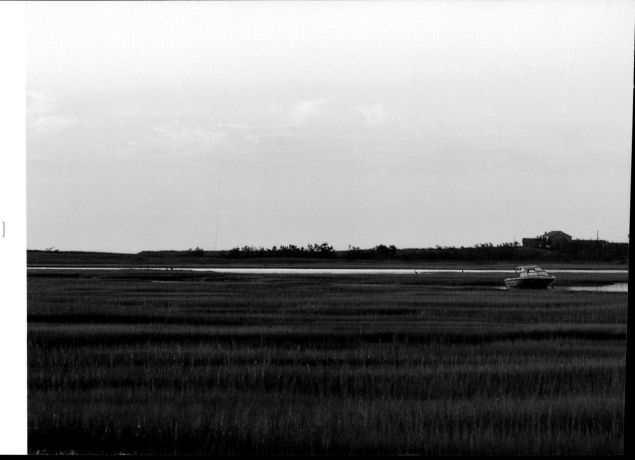

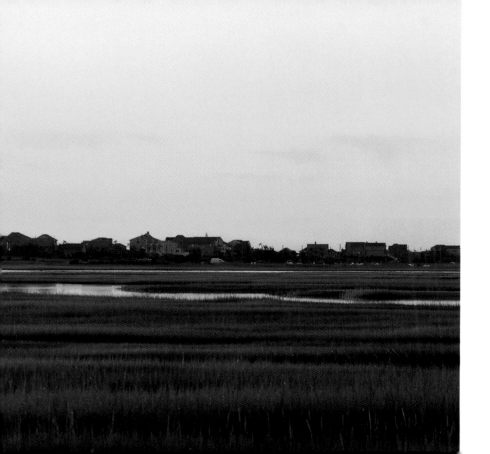

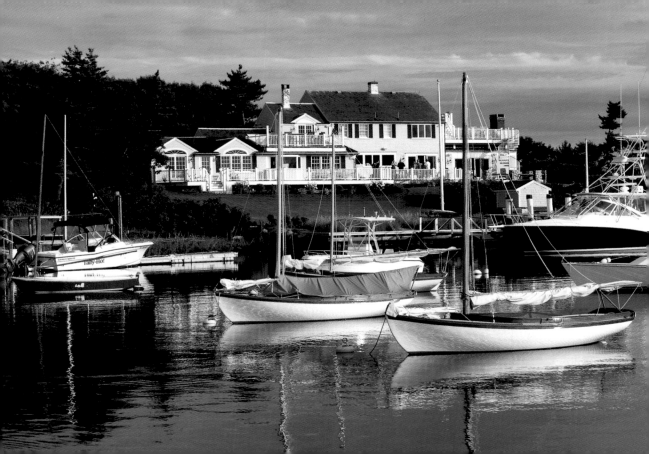

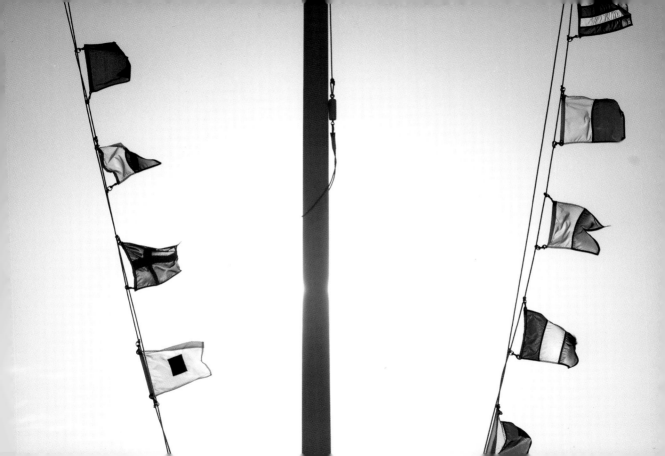

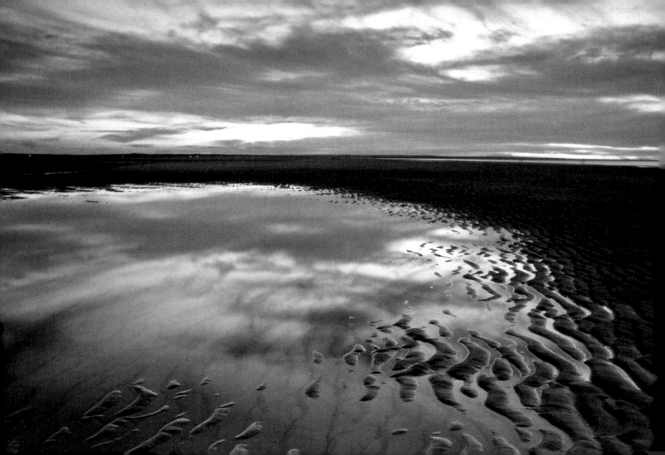

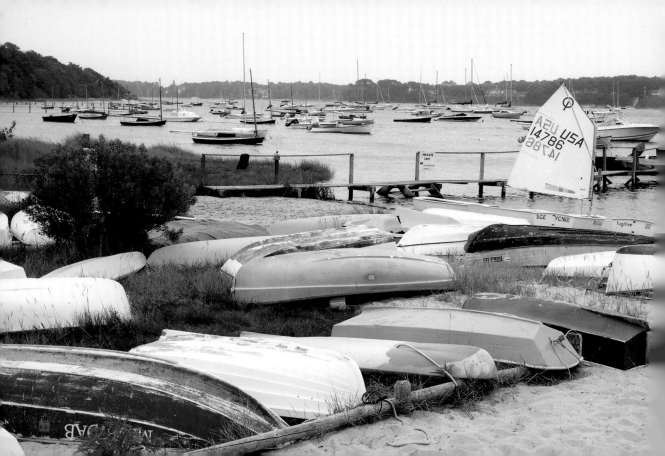

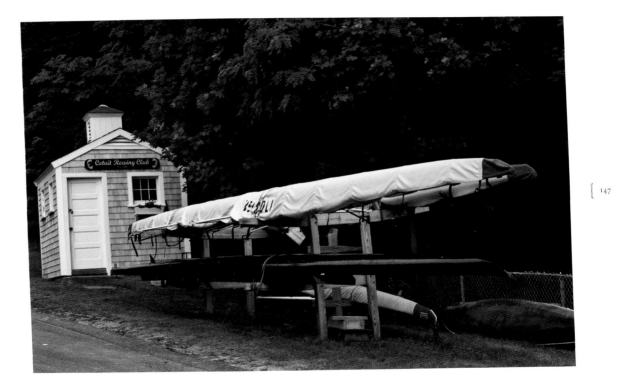

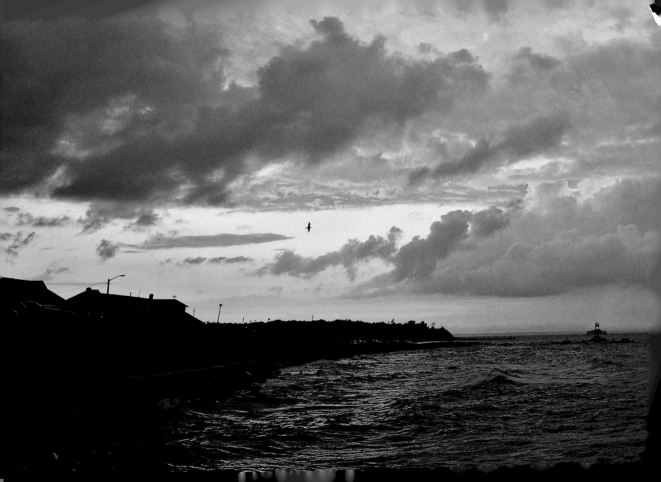

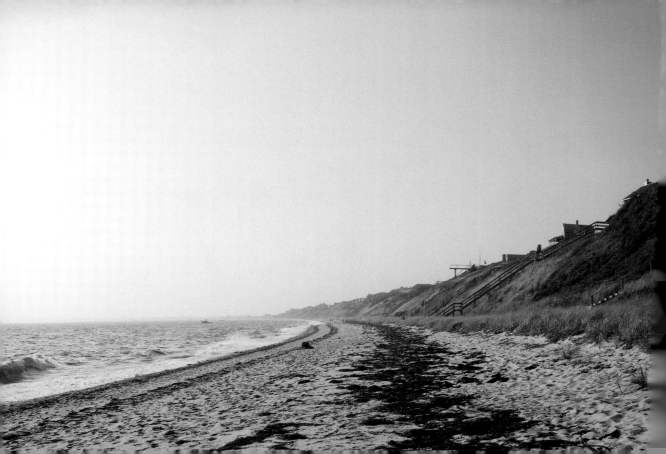

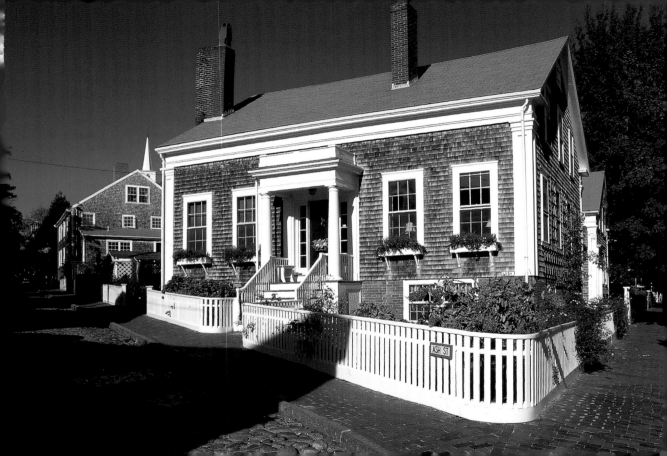

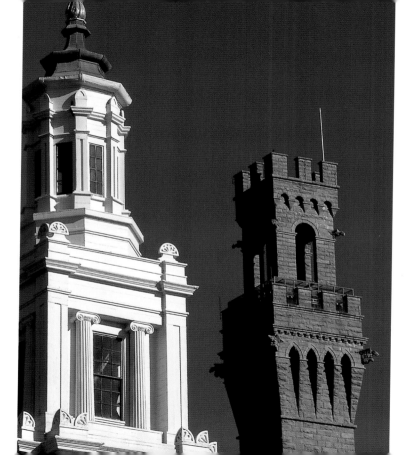

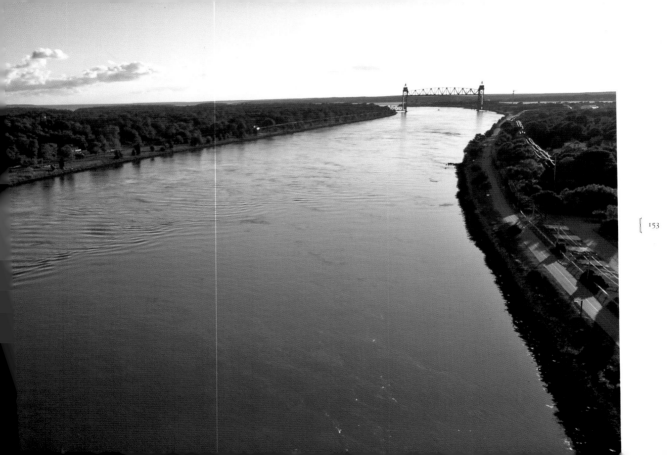

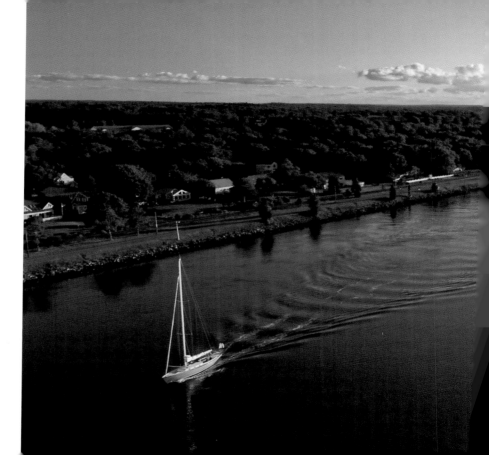

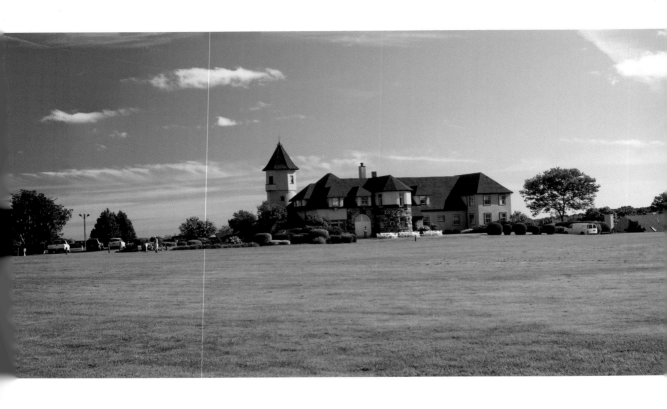

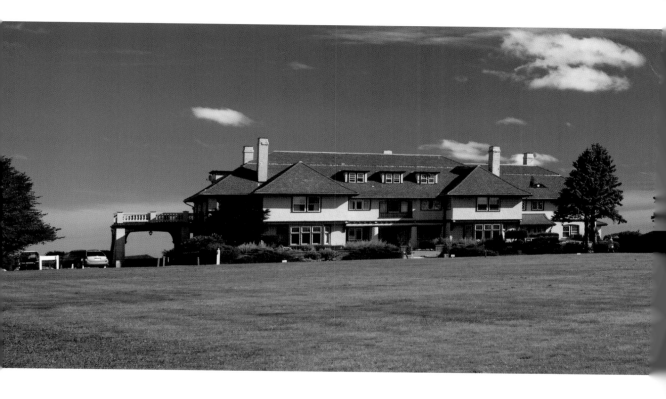

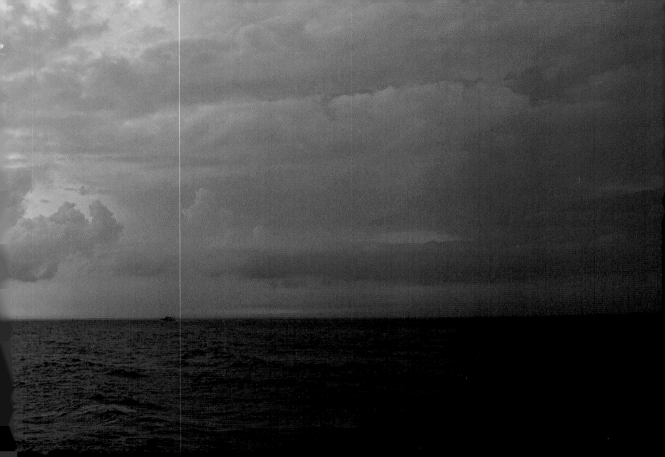

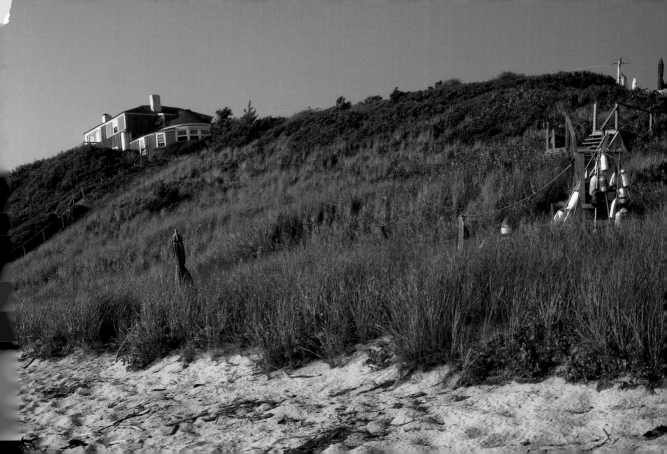

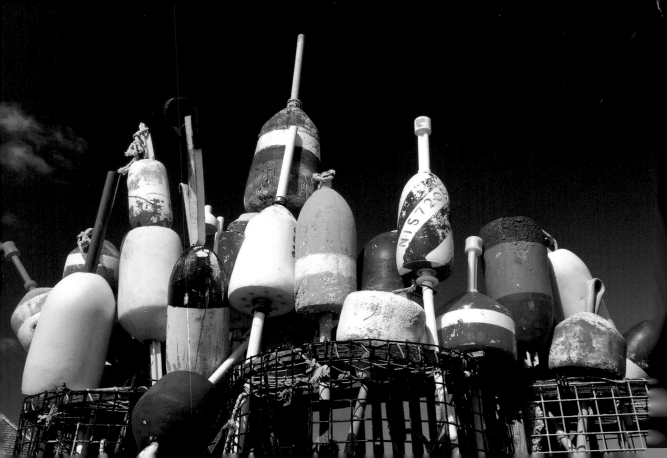

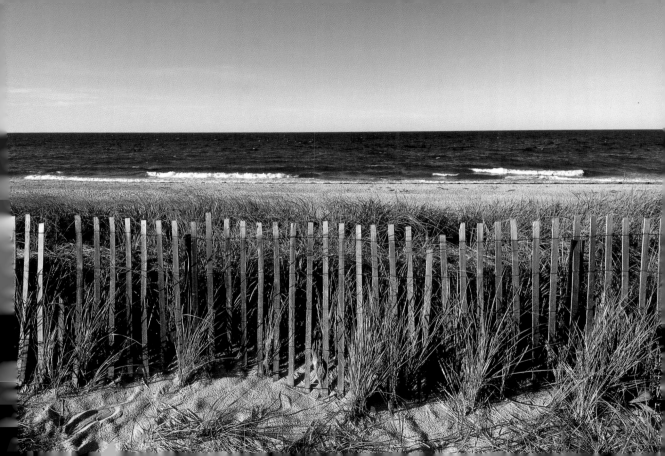

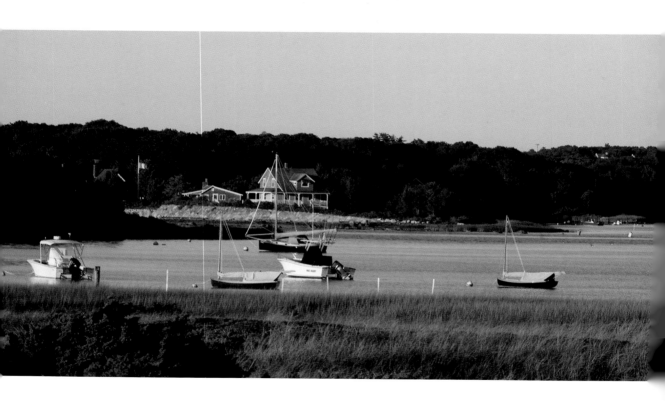

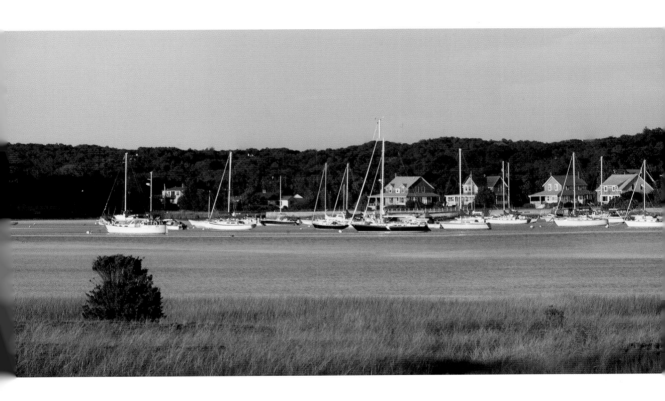

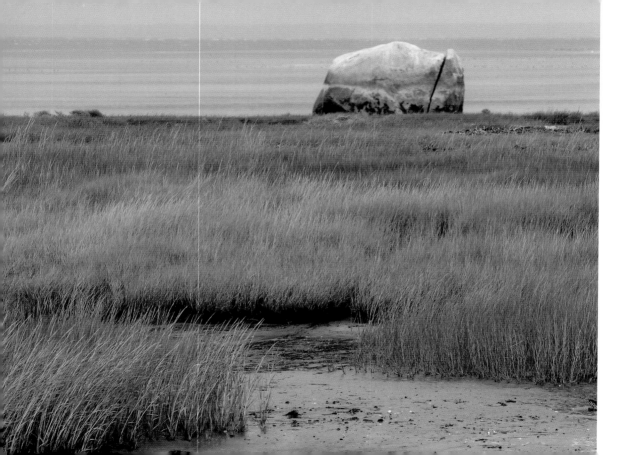

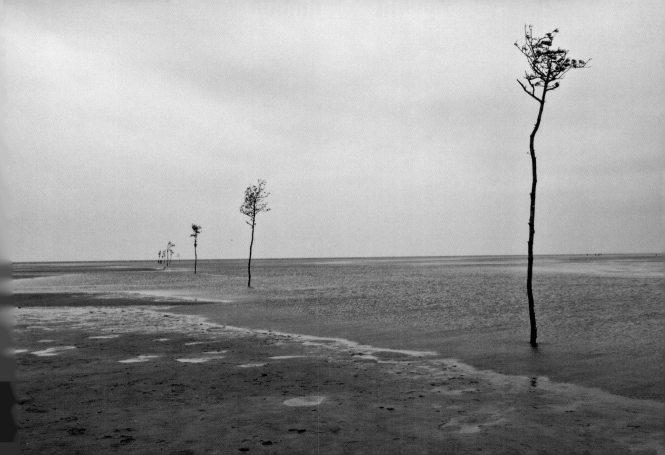

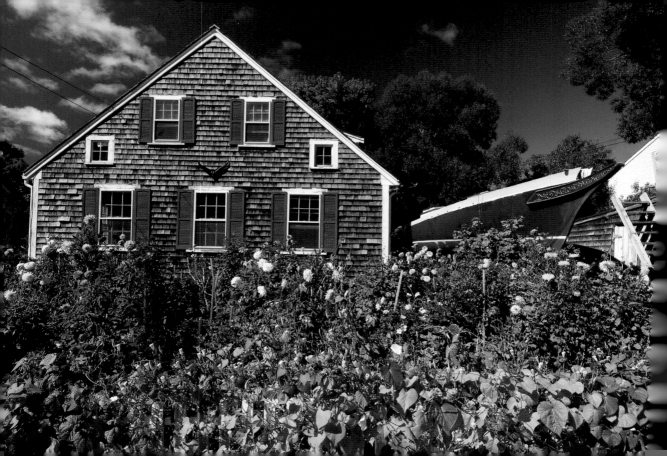

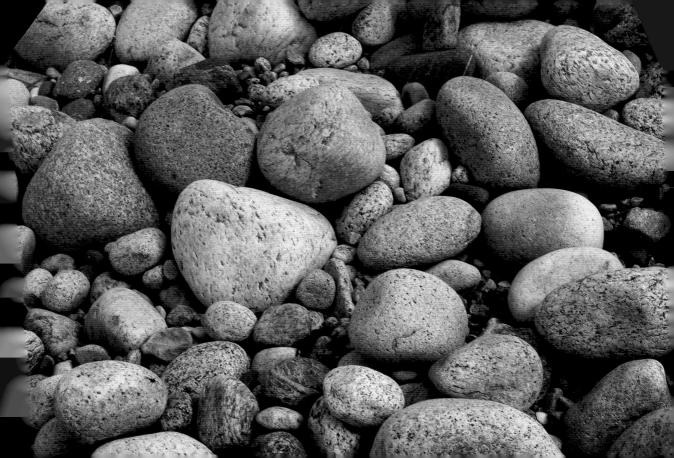

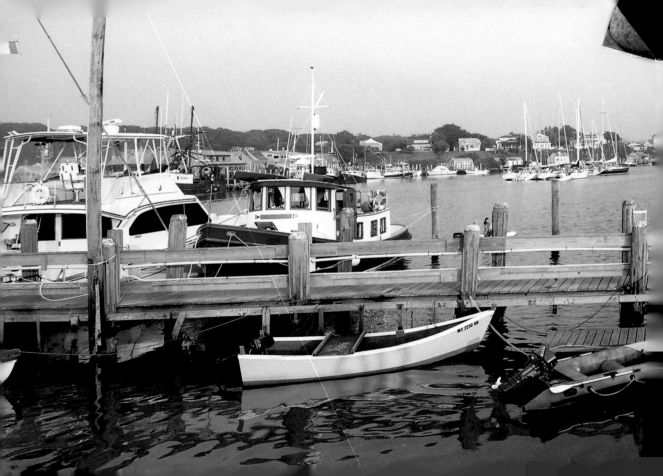

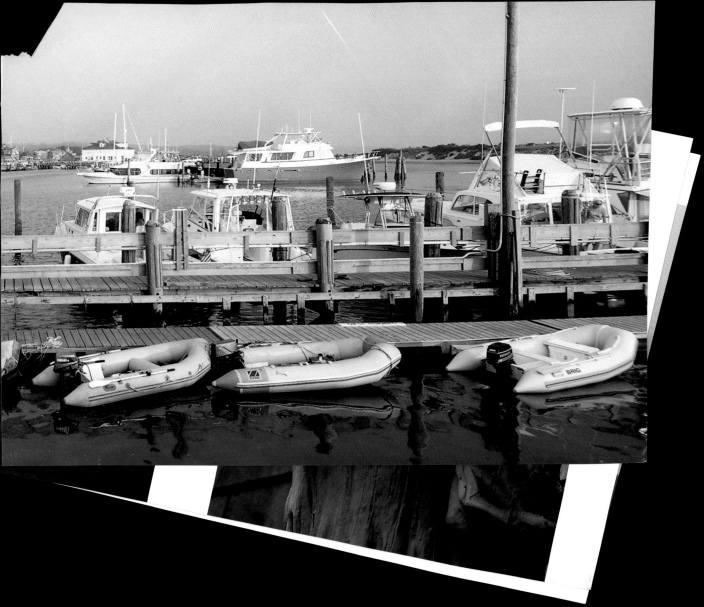

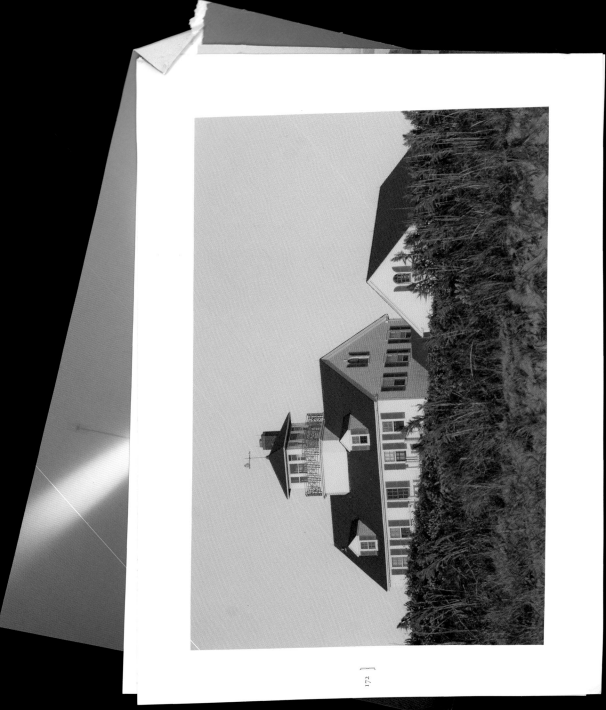

172

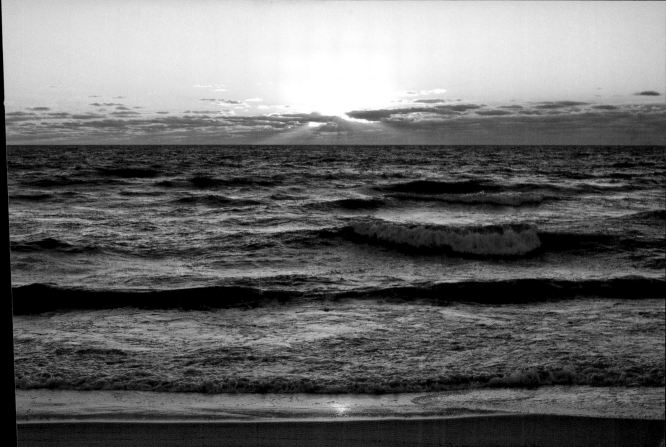

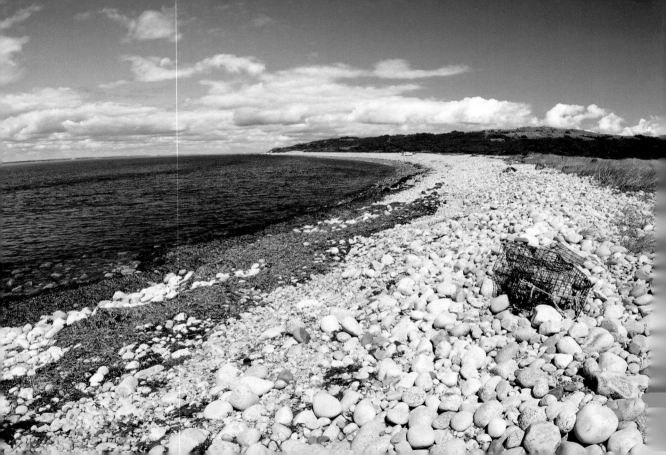

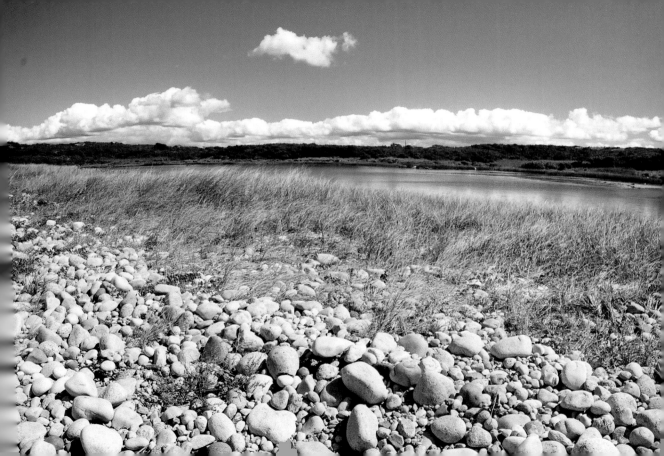

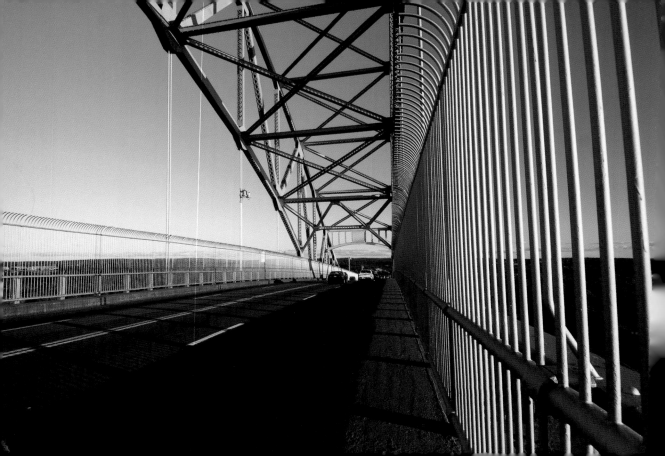

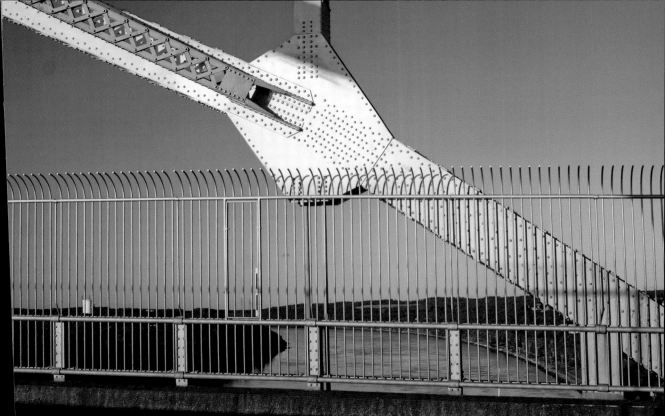

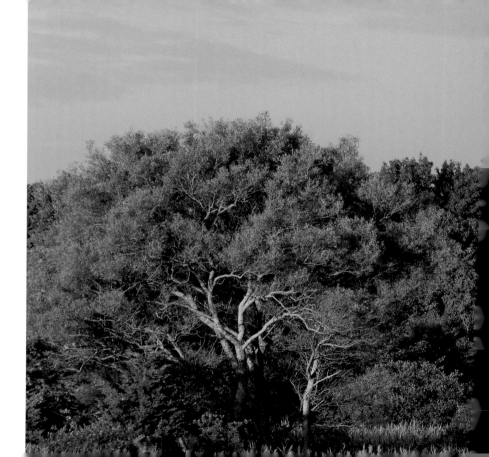

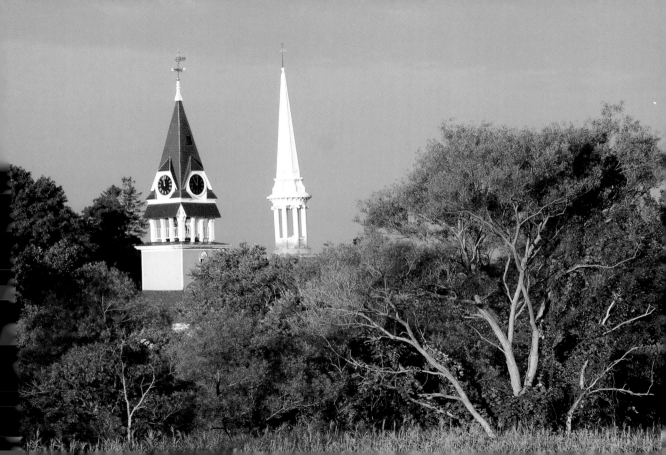

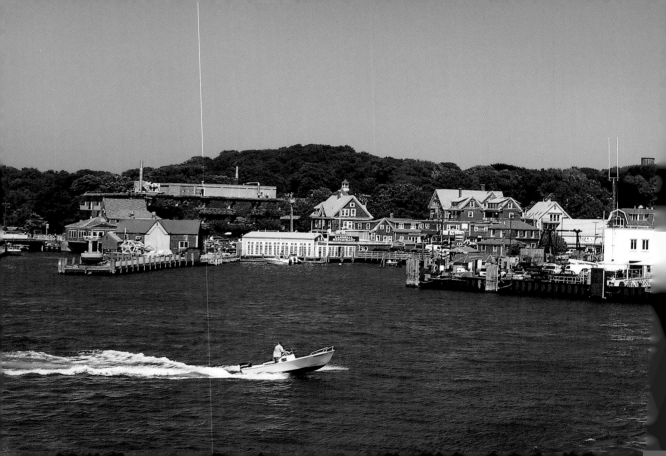

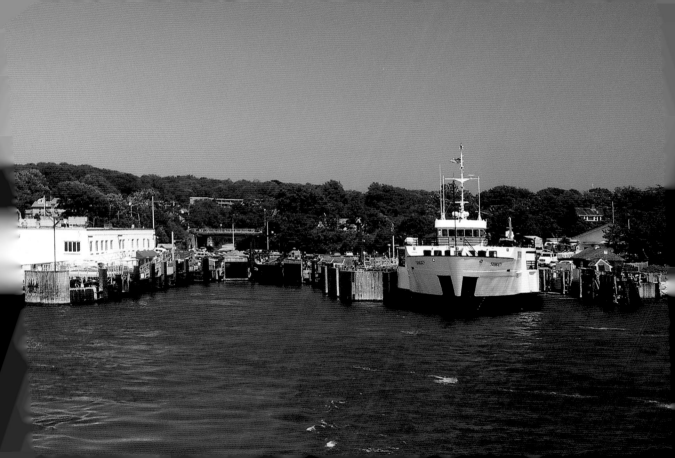

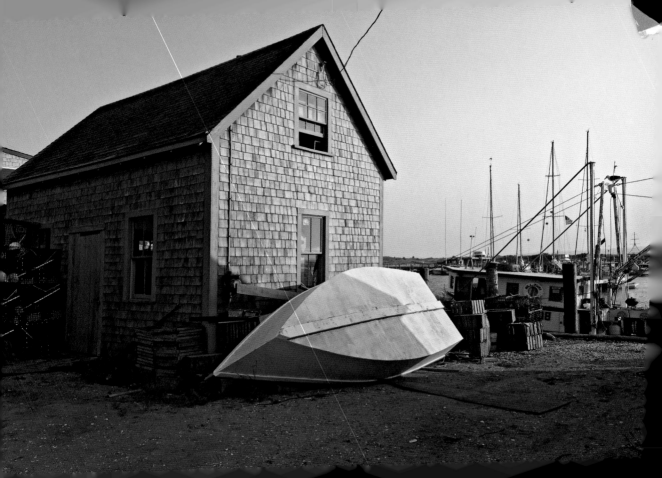

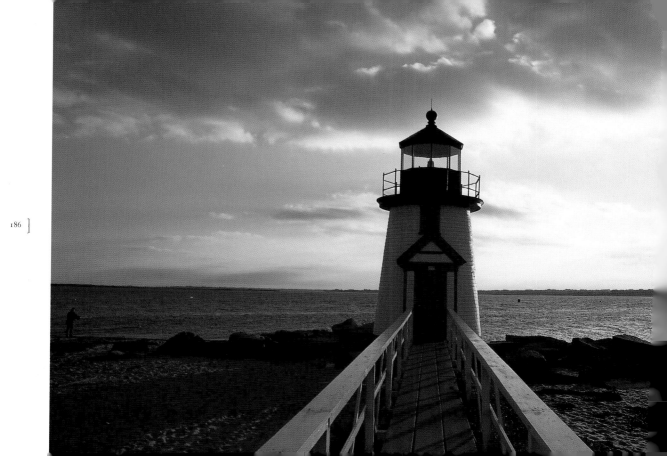

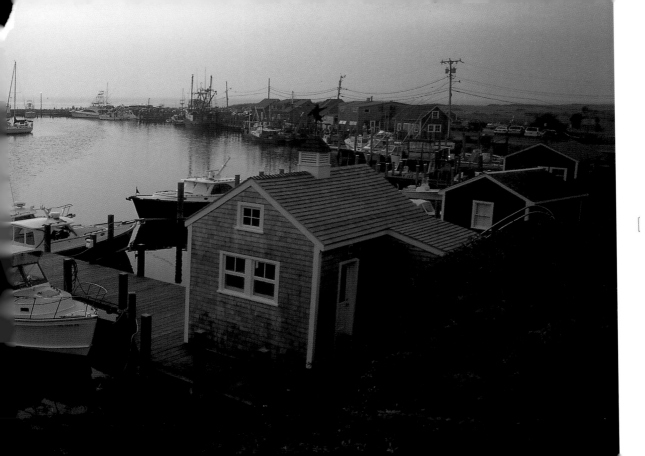

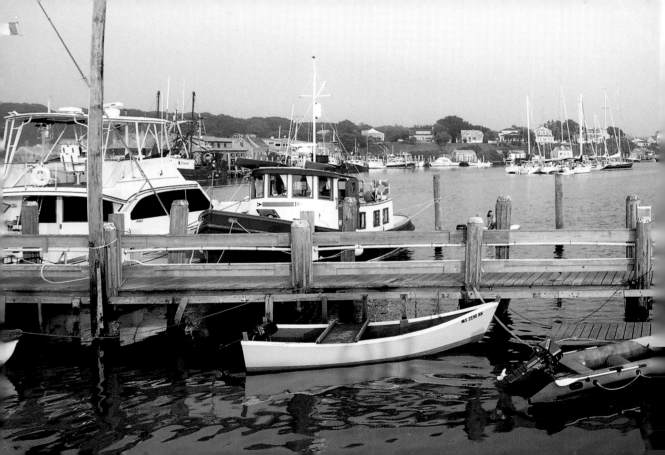

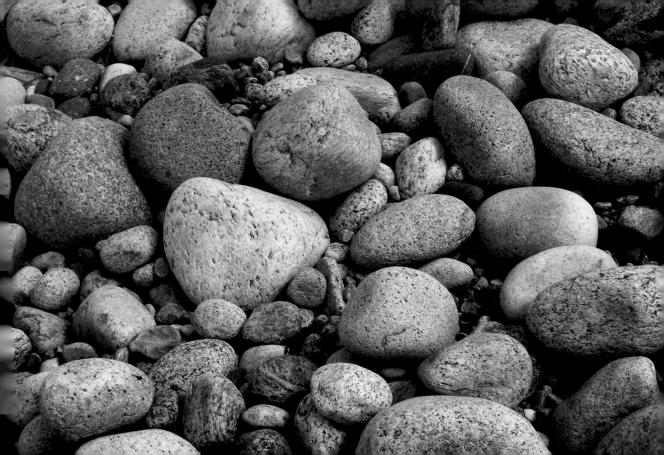

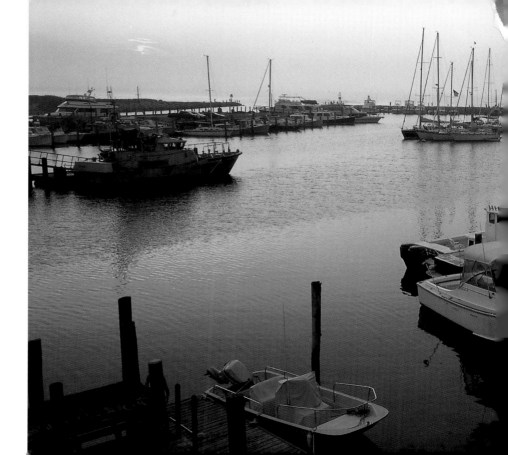

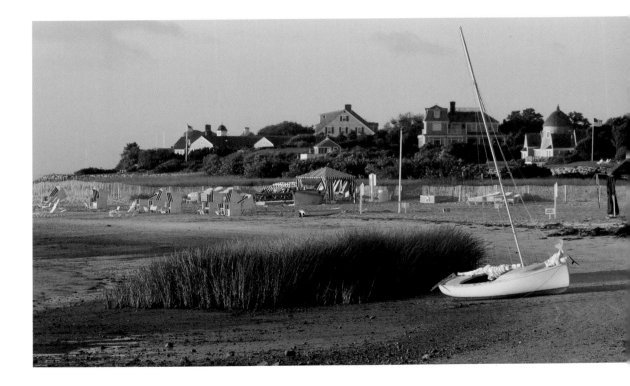

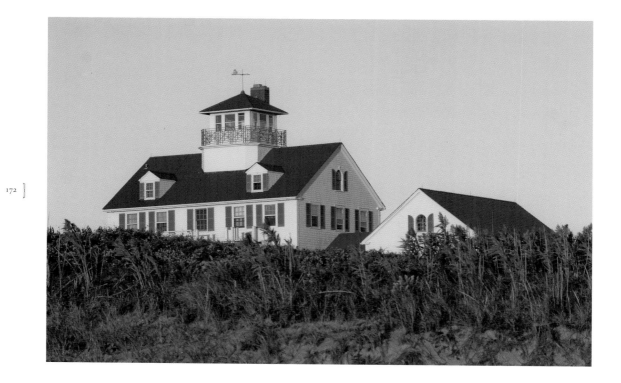

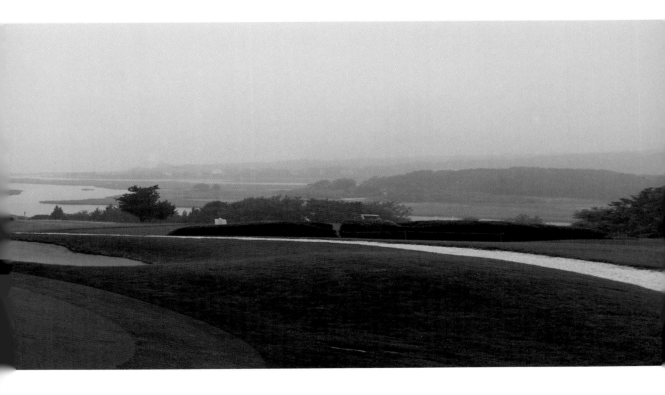

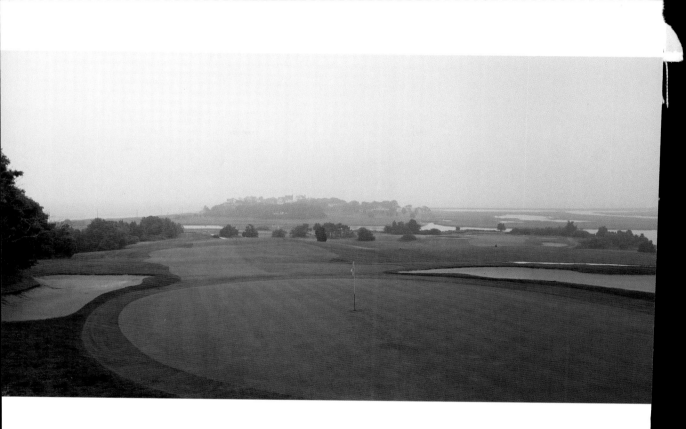

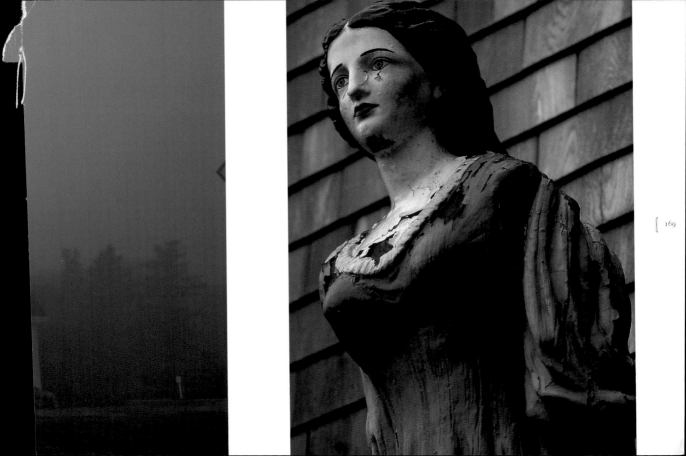

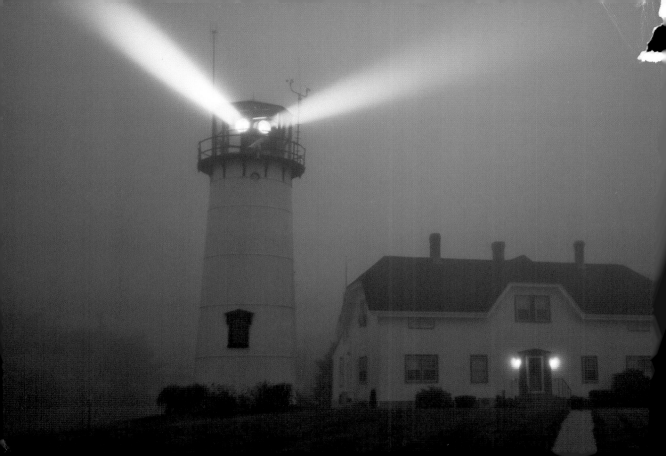

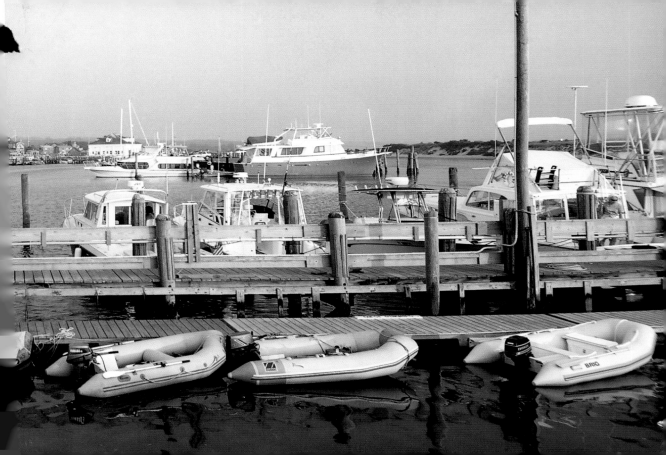

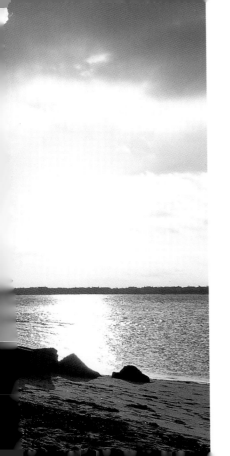

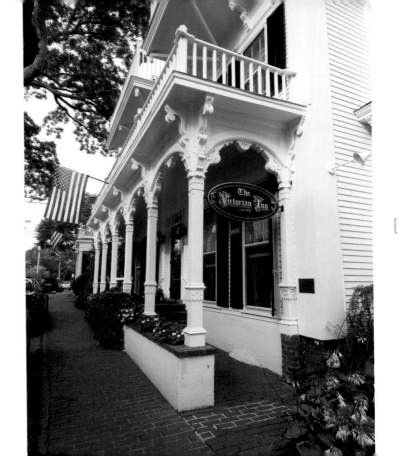

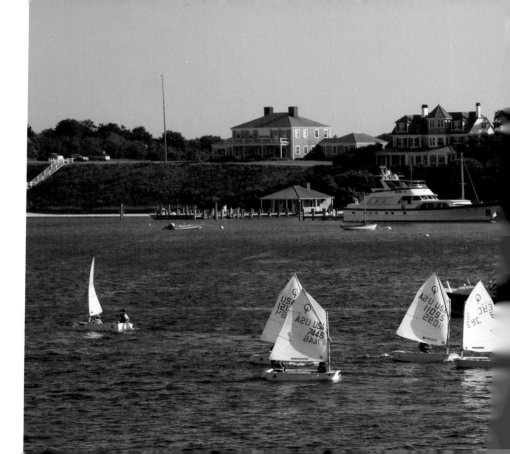

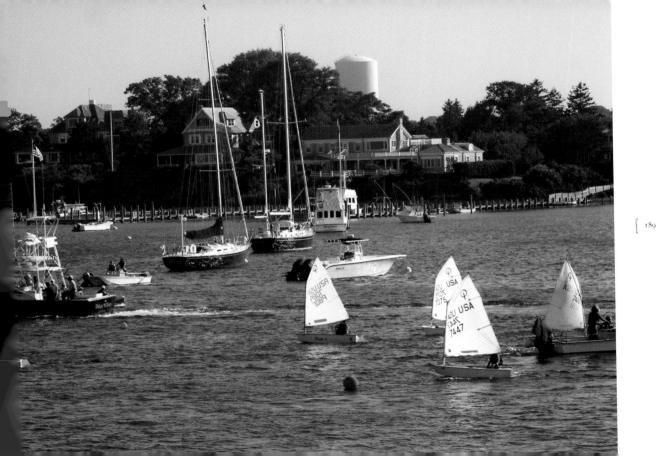

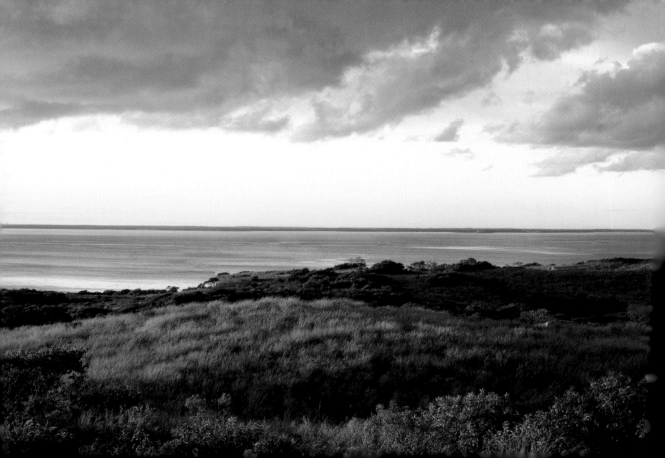

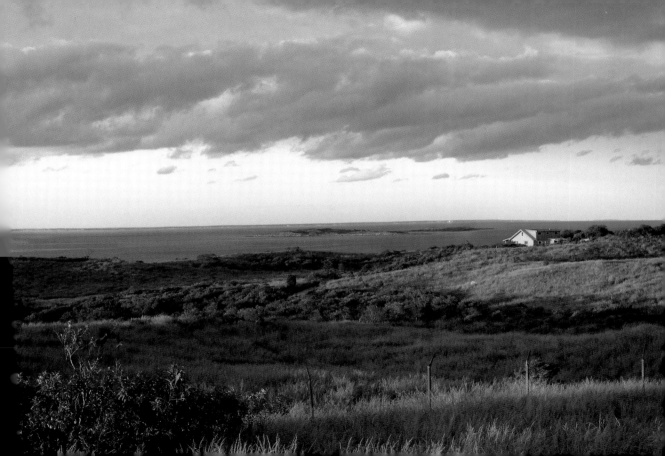

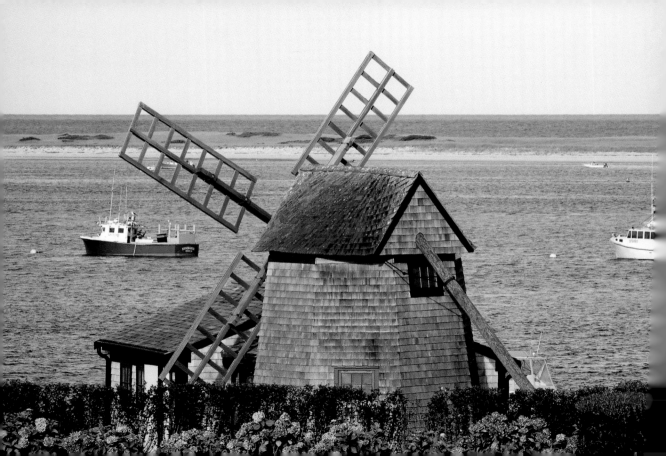

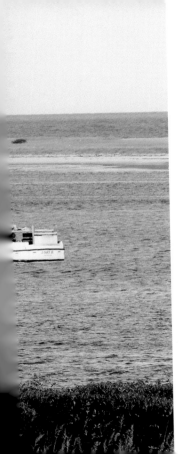

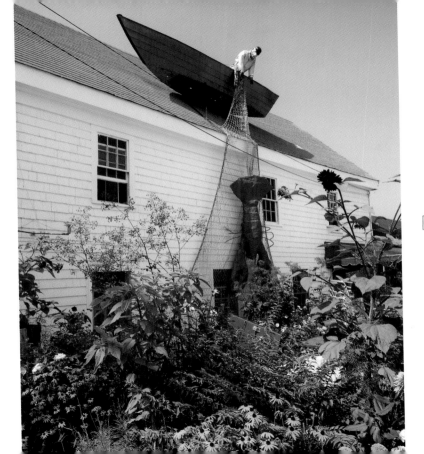

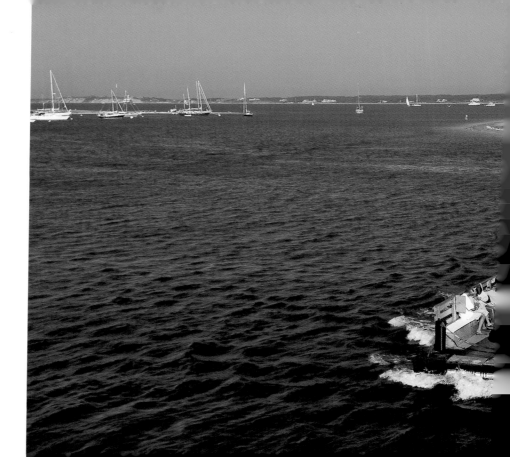

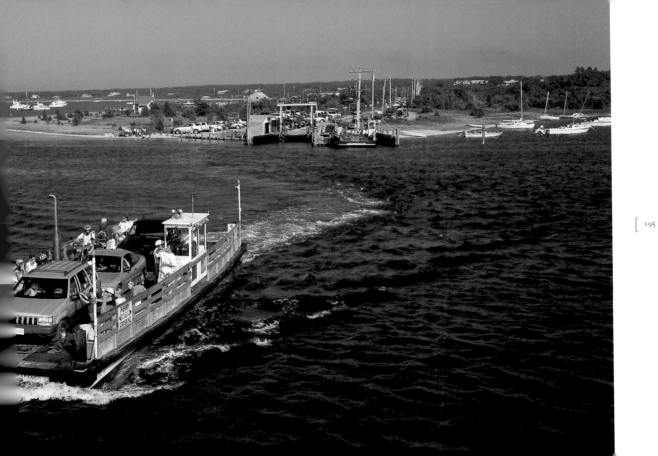

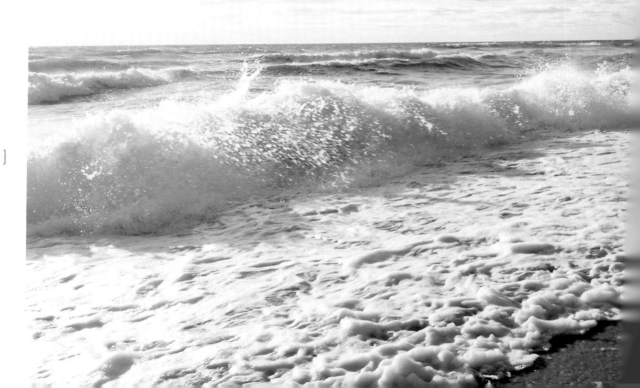

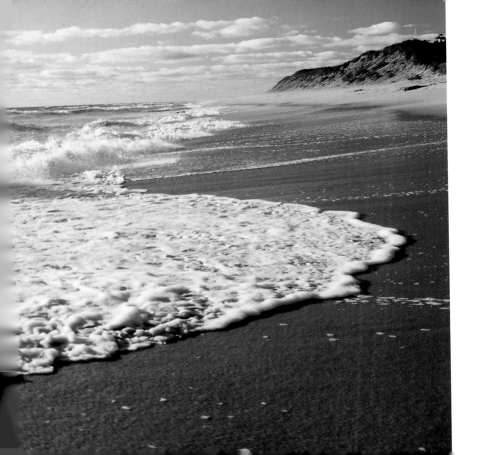

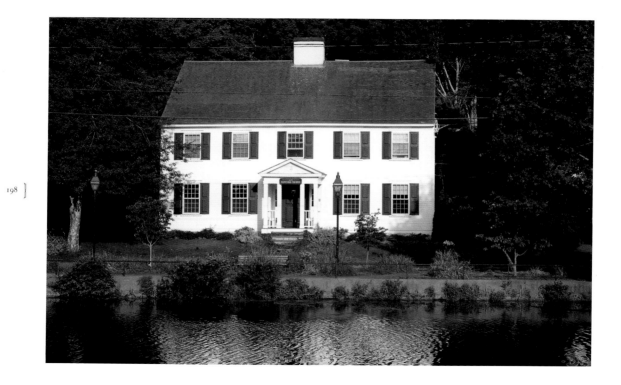

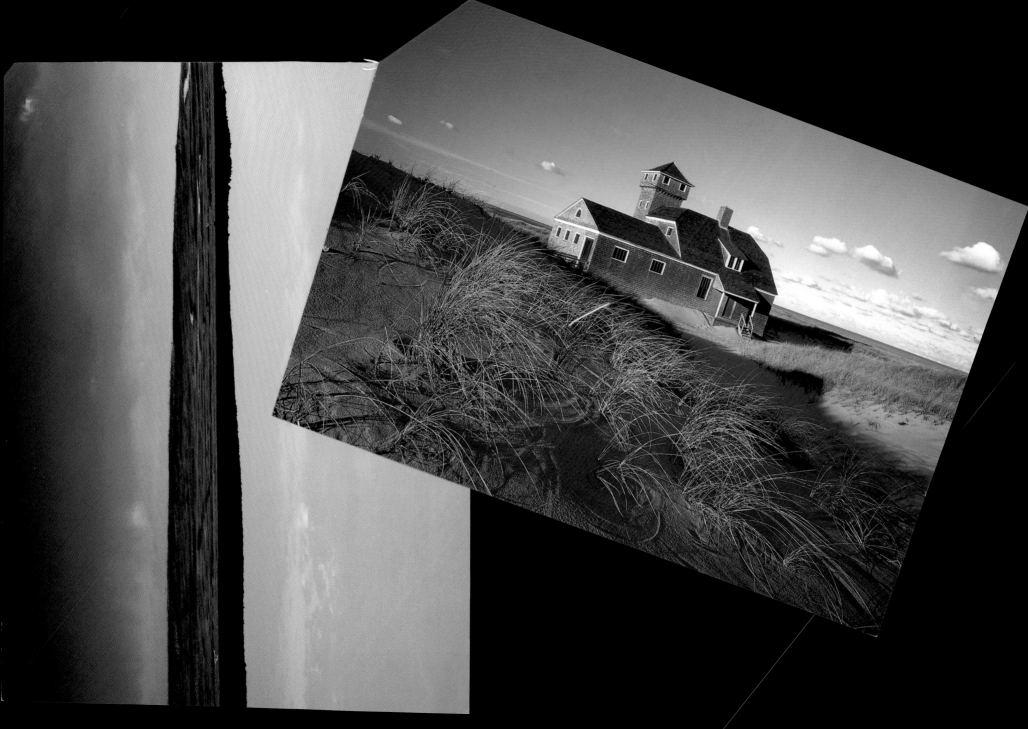

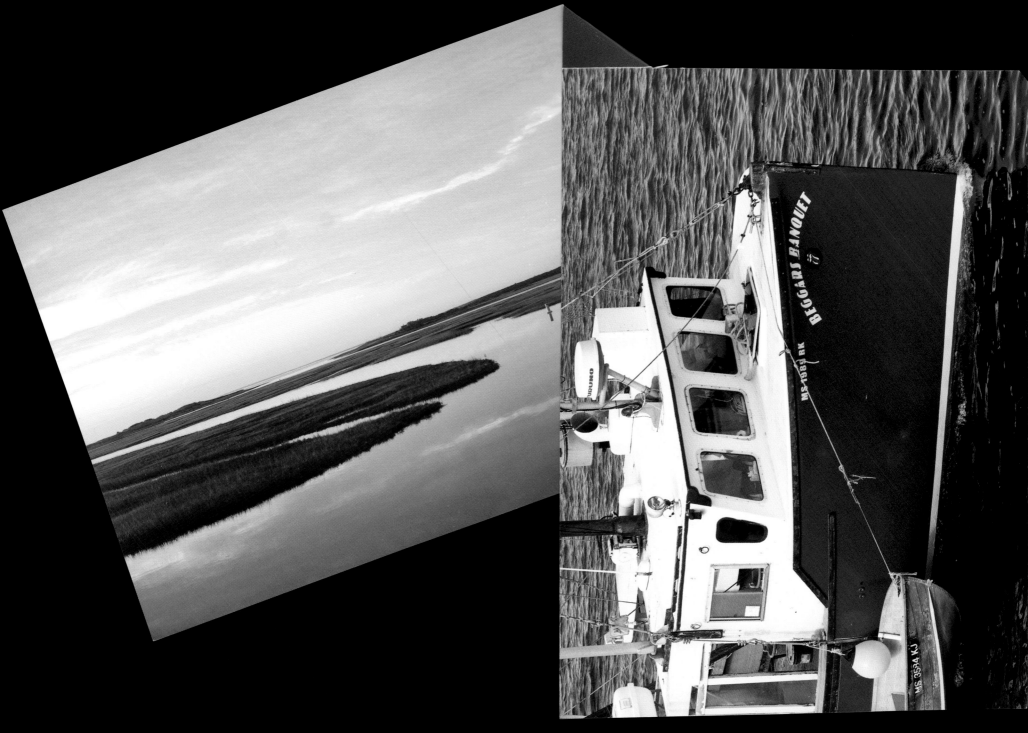

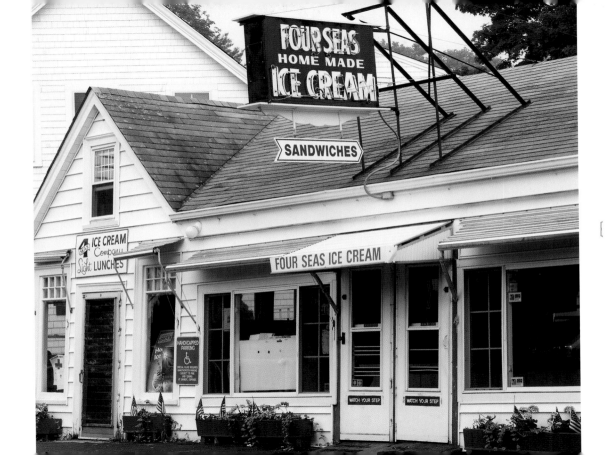

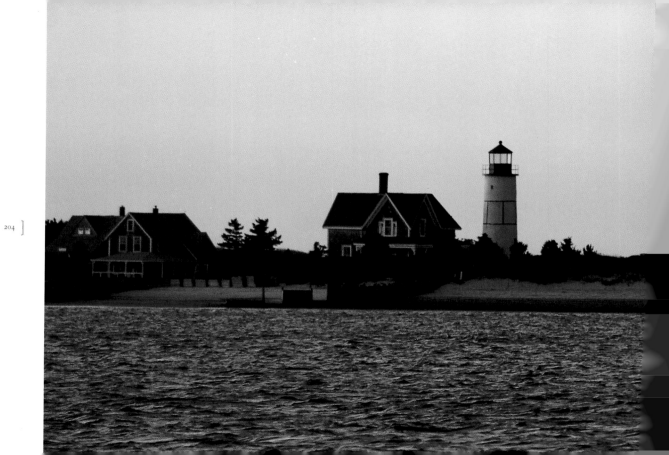

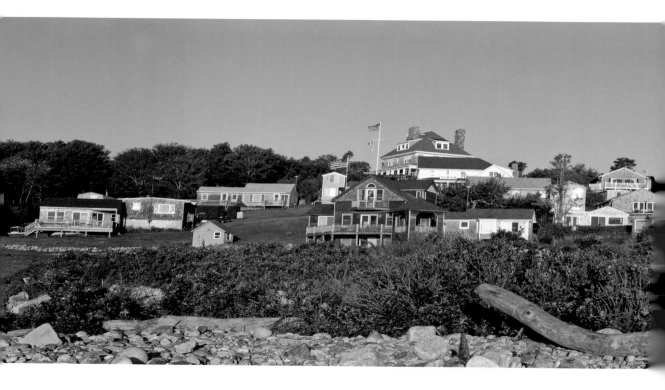

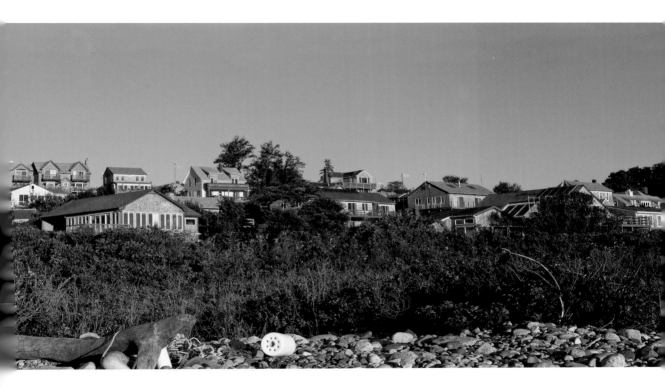

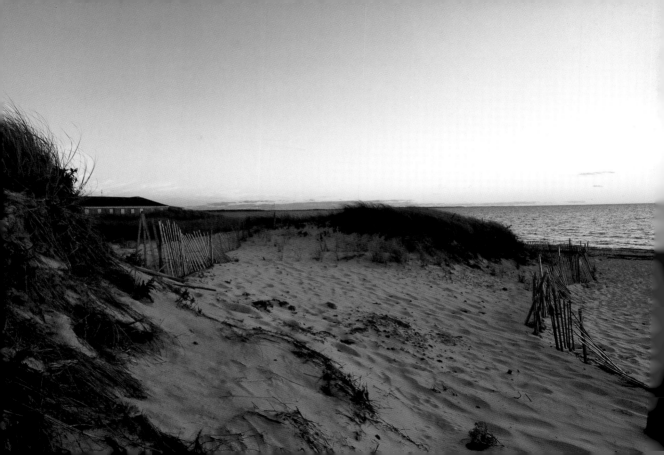

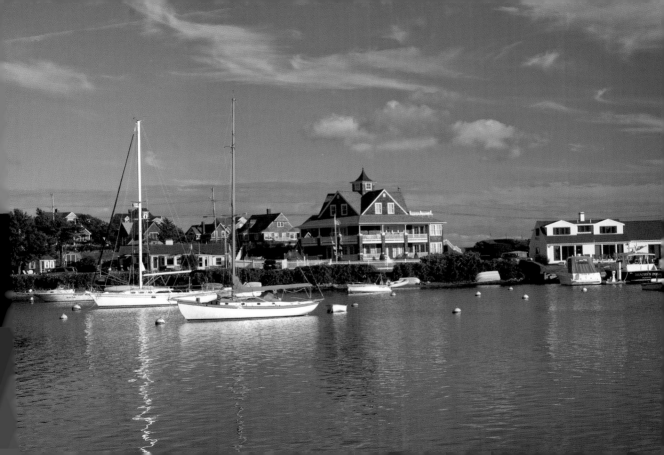

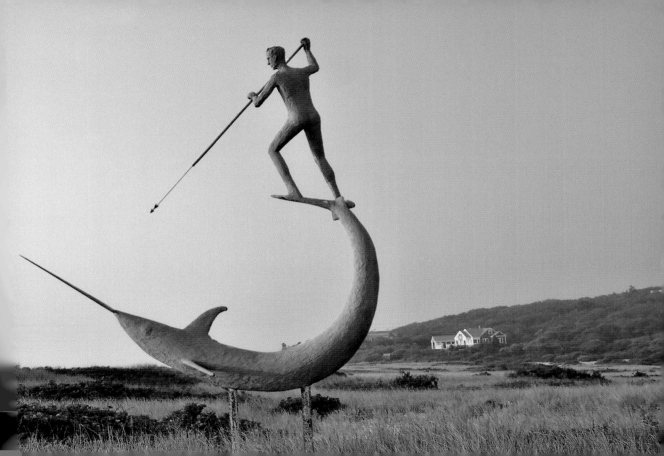

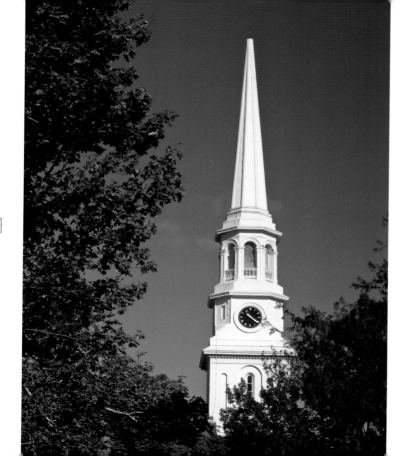

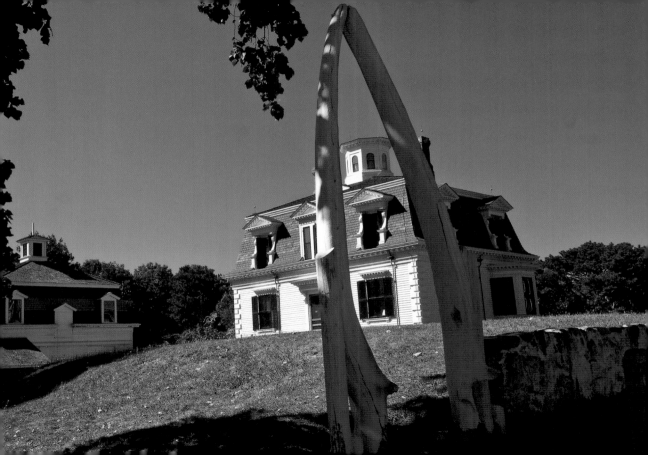

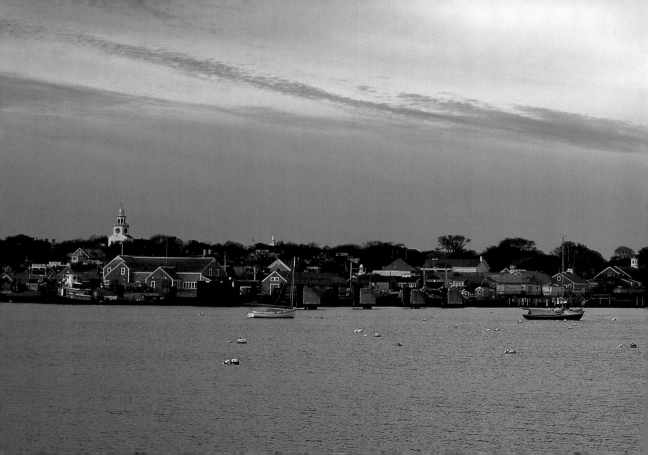

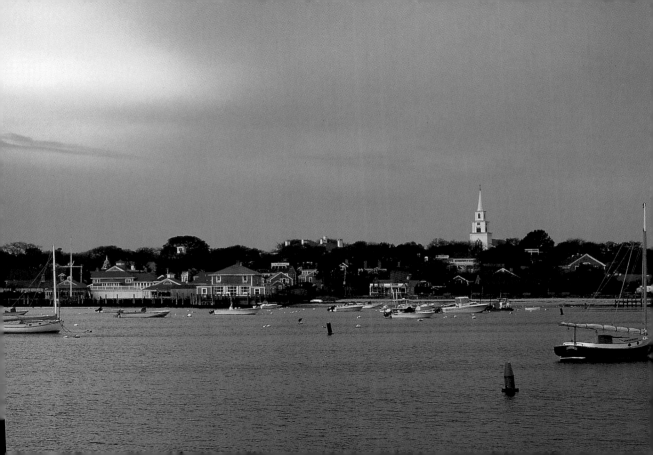

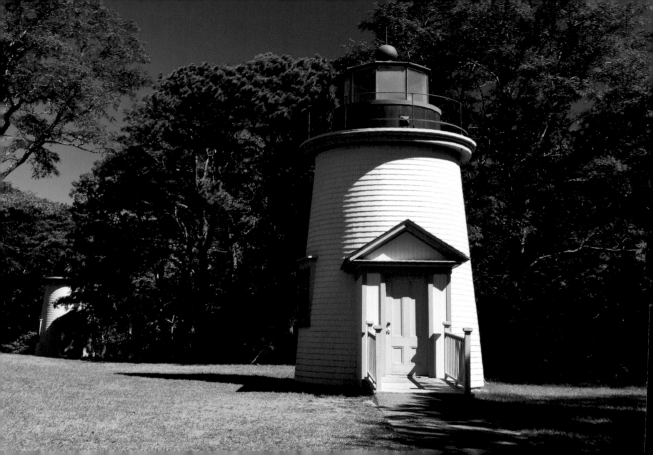

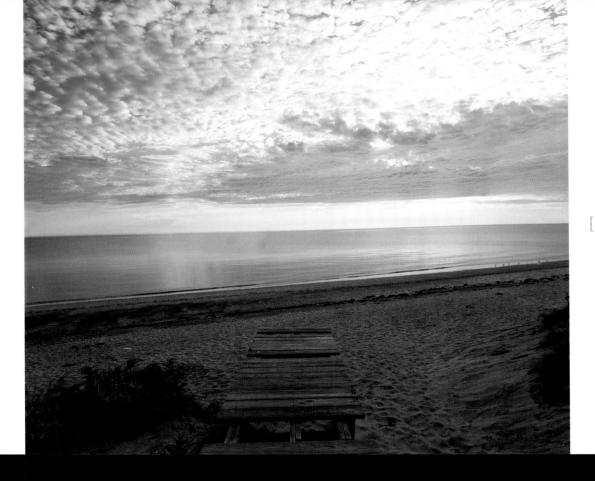

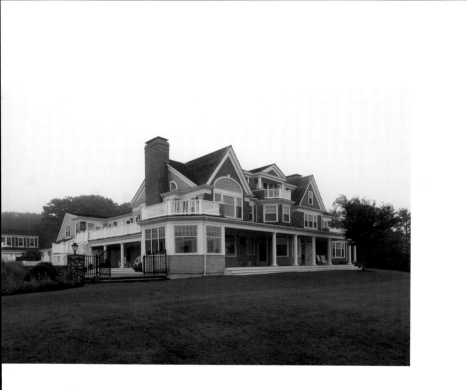
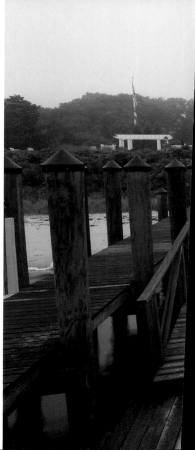

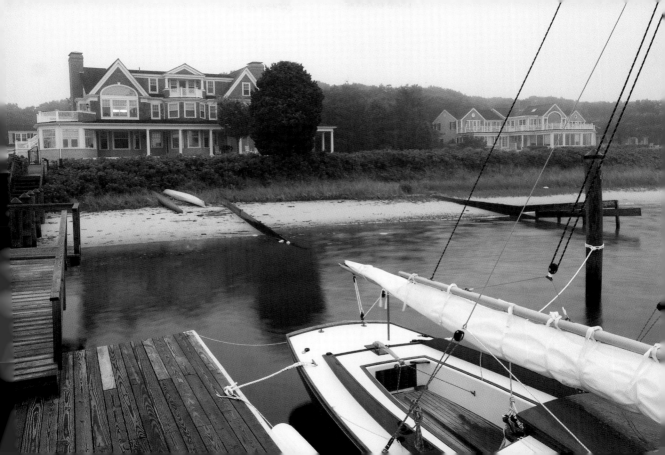

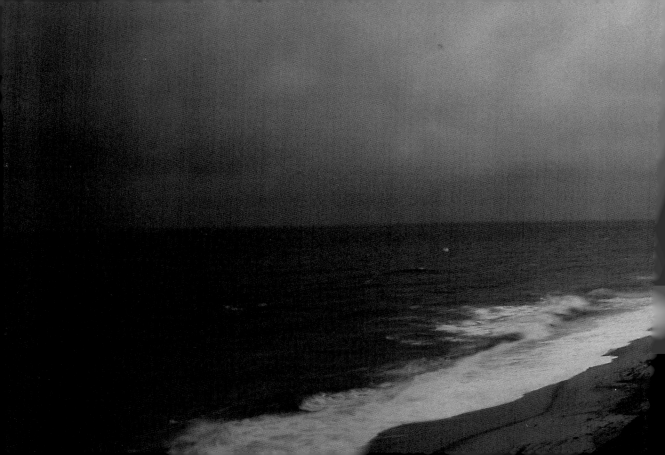

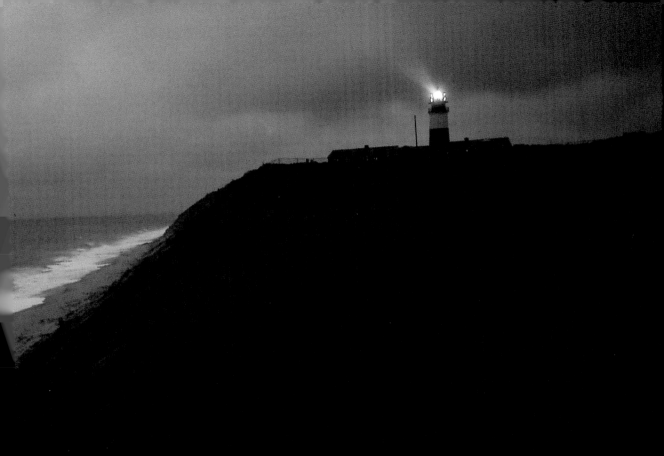

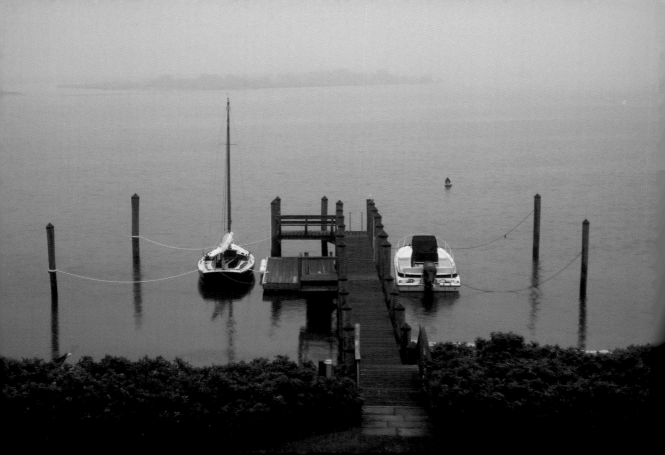

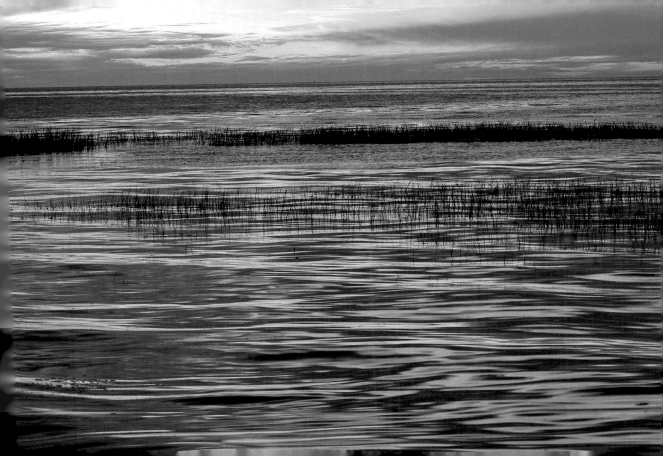

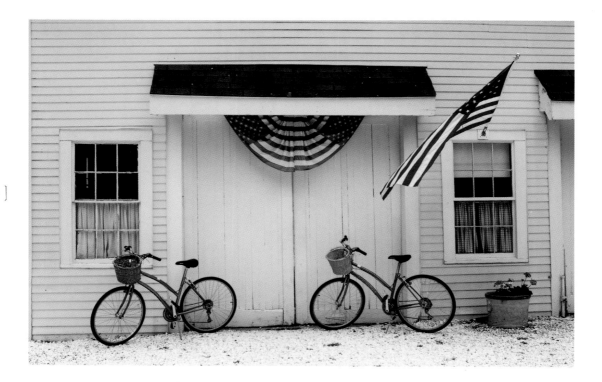

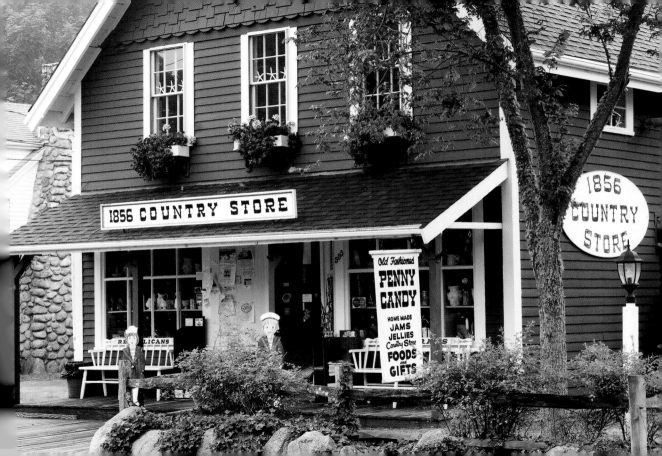

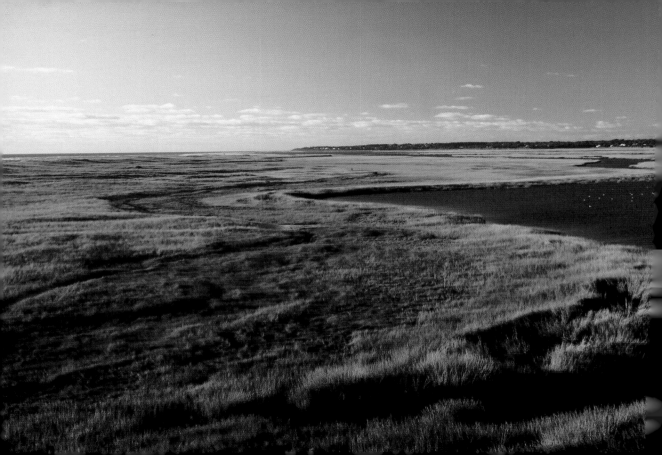

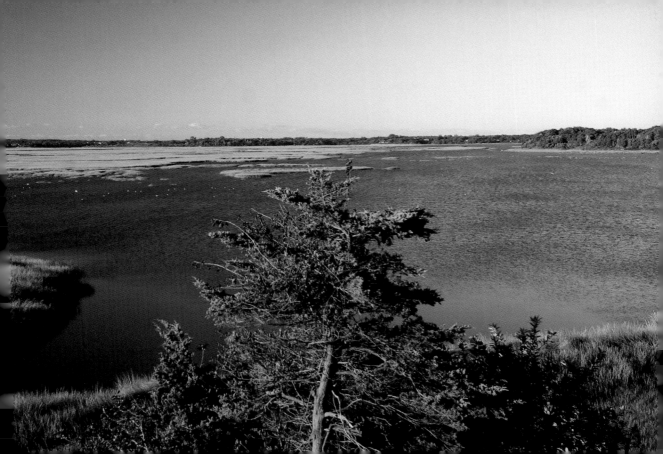

LIST OF PLATES

1: Hyannisport

2–3: Highland (Cape Cod) Light, Cape Cod National
 Seashore, Truro

4–5: Falmouth Heights

6–7: Cranberry bog, Harwich

8: Menemsha, Martha's Vineyard

9: Cap't Cass Rock Harbor Seafood, Orleans

10–11: Bourne Bridge and Cape Cod Canal, Bourne

12: Chatham Fish Pier, Chatham

13: Chatham Shore Road, Chatham

14–15: Gay Head Light, Aquinnah, Martha's Vineyard

16–17: Crosby Yacht Yard, Osterville

18–19: North Truro

20–21: Chatham Bars Inn, Chatham

21: North Water Street, Edgartown, Martha's Vineyard

22–23: Sandwich Boardwalk, Sandwich

24: Cuttyhunk Island

25: Avalon Inn, Cuttyhunk

26–27: Edgartown Light, Edgartown, Martha's Vineyard

28–29: Cape Cod National Seashore

30: Higgins Farm Windmill, Drummer Boy Park, Brewster

31: Main Street, Osterville

32–33: Stag Harbor, Chatham

34 and 35: Hoxie House, Sandwich

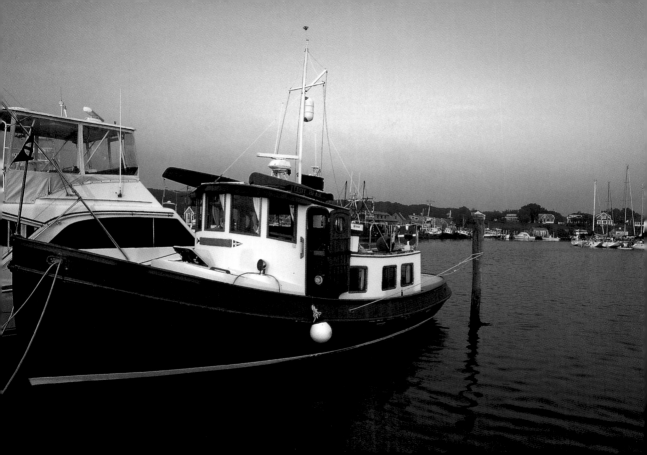

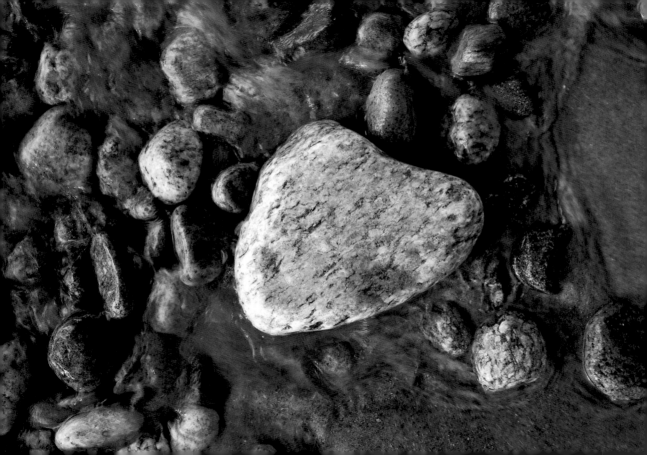

36–37: Cotuit Harbor, Cotuit

38–39: Sankaty Head, Nantucket

40: Falmouth

41: Hyannis Light and Ferry, Hyannis

42–43: Bodfish Park, Barnstable

44: Chatham Bars Inn, Chatham

45: Menemsha, Martha's Vineyard

46–47: Nantucket

48: Nobska Light, Woods Hole

49: Marine Biological Laboratory, Woods Hole

50–51: Cape Cod National Seashore

52–53: Nantucket

54: Cuttyhunk Elementary, Cuttyhunk

55: Cuttyhunk Methodist Church, Cuttyhunk

56: Wellfleet

57: Cuttyhunk Island

58–59: Paines Creek Beach, Brewster

60–61: Cotuit Harbor, Cotuit

62–63: Lobster traps, Falmouth Harbor, Falmouth

64 and 65: Provincetown

66: St. Andrews Episcopal Church, Hyannisport

67: Oyster Harbors, Osterville

68–69: Fort Hill Salt Pond, Eastham

70–71: Main Street, Falmouth

72–73: Chatham Break, Chatham

74: Brant Point Light, Nantucket

75: Lobster Pot Restaurant, Provincetown

76: Harwich Harbor, Harwich

77: Cape Cod Bay, Sandwich

78–79: Sankaty Light, Nantucket

80: Harwich Harbor, Harwich

81: Nantucket

82–83: Woods Hole Ferry, Oak Bluffs, Martha's Vineyard

84: Windmill Park, Eastham

85: Provincetown

86: Woods Hole

87: View off coast of Martha's Vineyard

88–89: Cuttyhunk Island

90: Oak Bluffs, Martha's Vineyard

91: Herreshoff, Harwich

92–93: Sandwich Boardwalk, Sandwich

94: Among the Flowers Café, Edgartown, Martha's Vineyard

94–95: Oak Bluffs, Martha's Vineyard

96–97: Chatham Fish Pier, Chatham

98 and 99: Aerial of Cape Cod

100–101: Cotuit Harbor, Cotuit

102–103: Moshup Trail, Aquinnah, Martha's Vineyard

104: Nantucket

105: Race Point Light, Provincetown
106–107: Truro
108: Rock Harbor, Orleans
109: Chatham Shore Road, Chatham
110–111: Chatham
112–113: Hyannis Harbor, Hyannis
114: Nantucket Sound
115: Menemsha, Martha's Vineyard
116–117: Bodfish Park, Barnstable
118: Dexter Grist Mill, Sandwich
119: Mariners' Lodge, Cotuit
120–121: Dead Neck Island, Osterville
122: Nantucket
122–123: Gay Head Light, Aquinnah, Martha's Vineyard
124–125: Cape Cod National Seashore
126–127: Chatham Bars Inn Beach, Chatham
127: Chatham Bars Inn, Chatham
128: The Brewster Store, Brewster
129: Edgartown Harbor, Edgartown, Martha's Vineyard
130–131: Cuttyhunk Island
132: First Church of Christ, Sandwich
132–133: Truro Vineyards, Truro
134–135: Falmouth Harbor, Falmouth
136: Julia Wood House, Falmouth

137: Chatham
138–139: Nantucket Harbor, Nantucket
140–141: Sandwich
142: Harwich Harbor, Harwich
143: Chatham Bars Inn, Chatham
144 and 145: Cape Cod Bay
146: Cotuit Harbor, Cotuit
147: Cotuit Rowing Club, Cotuit
148–149: Oak Bluffs, Martha's Vineyard
150–151: Ocean Edge Resort, Brewster
152–153: Cape Cod Canal, Bourne
154: View of The Pilgrim Monument, Provincetown
155: Nantucket
156–157: Truro
158: Provincetown Wharf, Provincetown
159: Bodfish Park, Barnstable
160–161: Snug Harbor, Falmouth
162 and 163: Rock Harbor, Orleans
164: Provincetown
165: Cuttyhunk Island
166–167: Menemsha Harbor, Menemsha, Martha's Vineyard
168–169: Chatham Light, Chatham
169: Nantucket
170–171: Hyannisport Club, Hyannisport

232

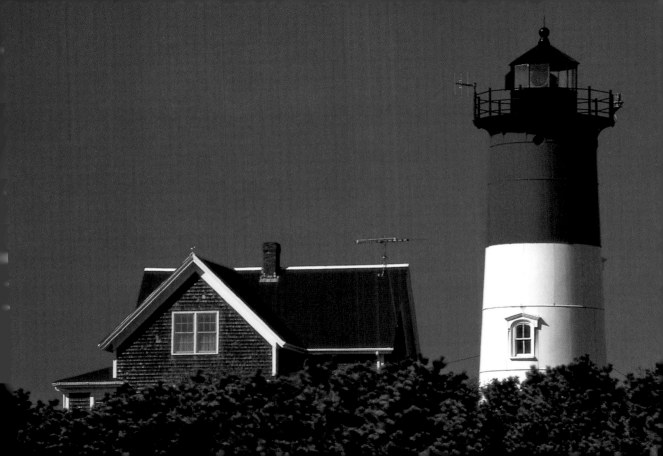

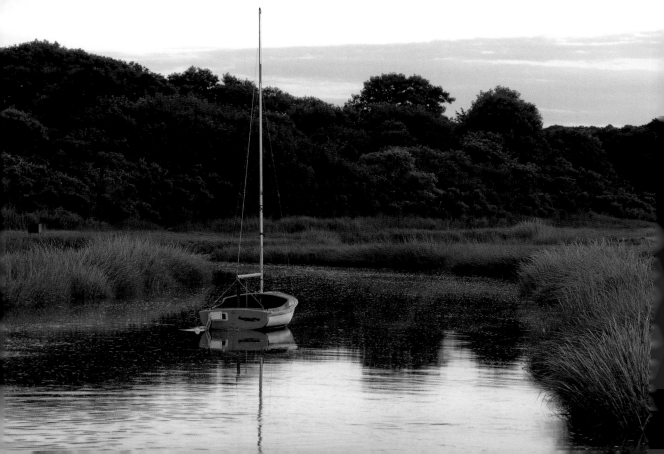

172: Coast Guard Station, Eastham
173: Coast Guard Beach, Eastham
174–175: Cuttyhunk Island,
176 and 177: Bourne Bridge
178–179: First Church of Christ and St. John's Episcopal
 Sandwich
180–181: Woods Hole Ferry, Woods Hole
182: Menemsha, Martha's Vineyard
183: Chatham Bars Inn Beach, Chatham
184–185: Menemsha Harbor, Martha's Vineyard
186–187: Brant Point Light, Nantucket
187: Victorian Inn, Edgartown, Martha's Vineyard
188–189: Edgartown Harbor, Martha's Vineyard
190–191: Cuttyhunk Island
192–193: Chatham Shore Road, Chatham
193: Mac's Shack, Wellfleet
194–195: Chappaquiddick Ferry, Martha's Vineyard
196–197: Nauset Beach, Eastham
198: Newcomb Tavern, Sandwich
199: Old Harbor Lifesaving Station, Race Point Beach
200–201: Old Harbor Creek, Sandwich
202: Chatham Fish Pier, Chatham
203: Four Seas Ice Cream, Centerville
204–205: Sandy Neck Light, Barnstable

206–207: Cuttyhunk Island
208: Chapoquiot Beach, West Falmouth
209: Falmouth Harbor
210–211: Menemsha, Martha's Vineyard
212: Congregational Church, Harwich
212–213: Captain Penniman House, Eastham
214–215: Nantucket
216: Three Sisters Lights, Eastham
217: Cape Cod Bay, Sandwich
218 and 219: Oyster Harbors, Osterville
220–221: Sankaty Light, Nantucket
222: View of Dead Neck Island and Nantucket Sound,
 Oyster Harbors, Osterville
223: Paines Creek Beach, Brewster
224: Old Manse Inn, Brewster
225: 1856 Country Store, Centerville
226–227: Nauset Bay, Eastham
229: Memensha
230: Cuttyhunk Island
232: Nauset Light, Nauset
234: Paines Creek Beach, Brewster
236: Nauset Beach, Eastham
239: Nantucket Harbor, Nantucket
240: Harbor seal, Chatham Fish Pier, Chatham

D E D I C A T I O N

To my wife, Amy: in appreciation of your warmth, love, and encouragement to keep creating books.

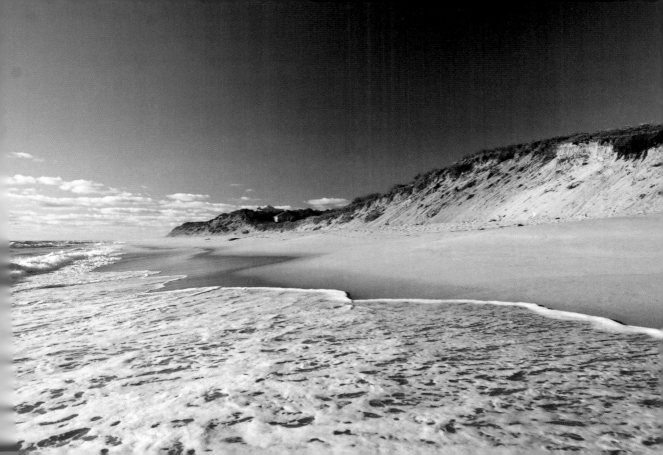

ACKNOWLEDGMENTS

I would like to thank the following people for their kindness and assistance in making this book possible:

Charles Miers, Kajia Markoe, and Maria Pia Gramaglia at Rizzoli International Publications, Inc.; Susi Oberhelman; Nick Iversen; David and Susan Kelly; Mark Speed; Jules Solo; and my editor, Jessica Fuller, for sharing her love of the Cape with me. Lastly, but not least my wonderful family; Amy, Chloe, Jack, Olivia, Sean, and Grace.